the photograph
guide to

Yosemite
& the High Sierra

Where to Find Perfect Shots and How to Take Them

Harold Davis

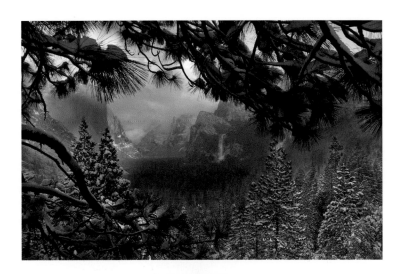

THE COUNTRYMAN PRESS
WOODSTOCK, VERMONT

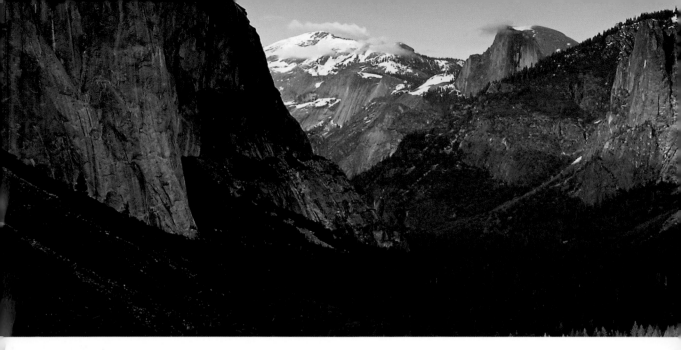

Text and photos copyright © 2008 Harold Davis

First Edition

ISBN 978-0-88150-762-1

Cover and interior photographs © Harold Davis
Cover and interior design by Susan Livingston
Cover and interior composition by Phyllis Davis
Maps by Paul Woodward © The Countryman Press

Published by The Countryman Press, P.O. Box 748, Woodstock, Vermont 05091
Distributed by W.W. Norton & Company, Inc., 500 Fifth Avenue, New York, NY 10110

Printed in China

10 9 8 7 6 5 4 3 2 1

Title Page Photo: Yosemite Valley snowstorm

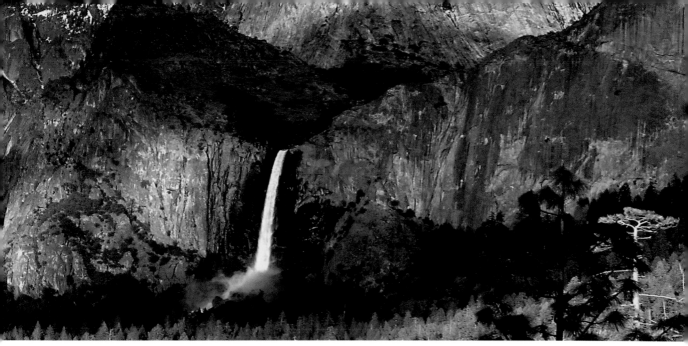

Yosemite Valley from Tunnel View

Contents

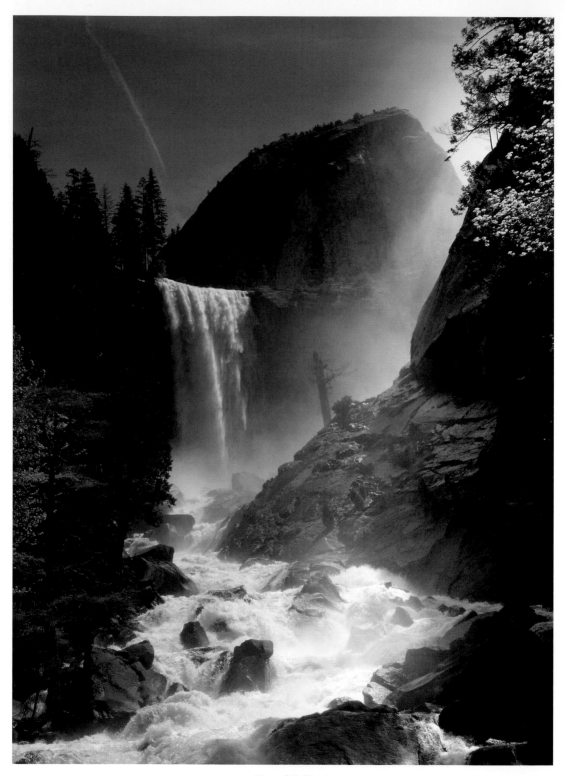

Vernal Falls

Introduction

Yosemite Valley in California's Sierra Nevada is one of the most photogenic, and photographed, places in the world. Words can't convey the awe-inspiring grandeur of Yosemite—which perhaps is why generations of artists and photographers have tried to capture the essence of the place.

Flowering dogwood

Yosemite combines the manifestation of ancient geological forces with the majesty of thundering waterfalls and the play of triumphant clouds and sky. No wonder Yosemite helped to inspire wilderness preservation and conservation movements, leading to the establishment of the United States National Parks.

In the late nineteenth century, naturalist John Muir wrote:

Yosemite Park is a place of rest, a refuge from the roar and dust and weary, nervous, wasting work of the lowlands, in which one gains the advantages of both solitude and society. Nowhere will you find more company of a soothing peace-be-still kind. Your animal fellow-beings, so seldom regarded in civilization, and every rock-brow and mountain, stream, and lake, and every plant soon come to be regarded as brothers; even one learns to like the storms and clouds and tireless winds. This one noble park is big enough and rich enough for a whole life of study and aesthetic enjoyment. It is good for everybody, no matter how benumbed with care, encrusted with a mail of business habits like a tree with bark. None can escape its charms. Its natural beauty cleans and warms like a fire, and you will be willing to stay forever in one place like a tree.

Today, millions of people visit Yosemite every year. During the high season of summer, Yosemite can seem like a hot and dusty metropolis of camping caravans rather than Muir's "place of rest."

But serenity waits patiently at every corner. It's all a matter of when, where, and how to find and "see" it. From a photographer's perspective, only an incremental difference separates a "me too" visit with nature and the resulting photograph from a transcendental wilderness experience that generates world-class imagery.

Also, Yosemite Valley can be a whole different story off-season in autumn, winter, and spring when the crowds have gone, and when in many ways nature is more beautiful than in the summer. Yosemite in winter is a photographer's dream!

Yosemite itself is but a small part, a crown jewel among many jewels, of the immense area that encompasses three national parks and several national forests, and composes the High Sierra region of the Sierra Nevada.

The goal of *The Photographer's Guide to Yosemite and the High Sierra* is to point you in the direction of superb photographic opportunities, not only as part of a traditional summer jaunt to Yosemite Valley but also in the broader context of all four seasons and the greater scope of the entire Sierra Nevada "range of light," as John Muir called it.

Yosemite and Landscape Photography

Yosemite plays a very special role in landscape photography. Photographic pioneers like Eadweard Muybridge and Carlton Watkins gained renown with their early images of Yosemite. Ansel Adams created bravura black-and-white prints from his iconic imagery of Yosemite as wilderness at its finest, and in the 1930s traversed the Sierra Nevada by auto and mule with his large format camera.

Art critic Rebecca Solnit suggests that Yosemite appealed to early photographers because with "its greenness, its water, its enclosure, its often misty atmosphere, it was for easterners an island of familiar aesthetic appeal in the ocean of strangeness of the arid plains, deserts, and mountains of the West."

Whether because Yosemite is "an island of the familiar," or more simply because of its innate magnificence and beauty, Yosemite has been a magnet for landscape photography ever since its "discovery" in 1851 when a small unit of American soldiers blundered into the valley in the course of a mission to forcibly remove indigenous peoples to a reservation.

Steller's jay

Word of Yosemite's wonders swiftly spread. Over time, photography of Yosemite helped to enhance the appeal of Yosemite and the Sierras as a travel destination and, symbiotically, the very appeal of the familiar Yosemite landmarks helped promote landscape photography as a very American art form intertwined with the grandeur of western scenery.

Hundreds of thousands, if not millions, of people take photos of Yosemite and the Sierras every year. If you have been one of them, or are planning a trip to the region with your camera, and good photography is important to you, you will be inspired by this region's significant role in the history of landscape photography.

Using this Book

This introduction provides general background information about Yosemite, the Sierras, and photography in the region. The book is divided into six geographic sections: I. Yosemite Valley, II. Glacier Point, III. Tuolumne and Tioga, IV. Western Sierra, V. High Sierra Trails, and VI. Eastern Sierra and Owens Valley.

Each of these chapters includes photographs to give you some idea of what you can expect when you visit, although of course conditions such as weather and light are never the same twice. You'll also find access and resource information, and photography tips, in each chapter.

The appendixes at the end of the book provide suggestions for further reading, general trip-planning resources, information about places photographed by Ansel Adams, and data about phases of the moon, seasonal highlights, and natural phenomena that may come in handy if you are planning a trip with your camera.

Understanding the Region

From Walker Pass in the south to Carson Pass in the north, the High Sierra crest stretches almost 300 unbroken miles. Take a look at the maps of Sierra Nevada north and south on pages 8 and 9.

If you want to cross the mountains along this crest, you can do it only on foot or, in a vehicle, on one or two small, winding roads (CA 108 over Sonora Pass, and CA 120 over Tioga Pass in Yosemite National Park; see Chapter III starting on page 57) that are subject to lengthy seasonal closures for snow.

This is a region of superlatives: the highest mountain in the continental United States (Mount Whitney), the deepest valley (Owens Valley), the largest tree (in Sequoia National Park), the oldest living thing (in the Ancient Bristlecone Pine Forest).

The Sierras include three national parks and fall under the jurisdiction of a number of different federal agencies. In addition to Yosemite, Kings Canyon, and Sequoia National parks, parts of the Sierras are also in national forests: Stanislaus, Toiyabe, Sierra, and, most significantly, Inyo National Forest.

Yosemite Valley is a deep cleft in the Sierra range with a narrow entrance. Its massive and distinctive landmarks are clearly recognizable from the air on a transcontinental flight. The valley floor is at a moderate 3,000-foot elevation, so it is accessible year-round, at times when travel to the higher country of the Sierra would require an extensive journey on snowshoes or cross-country skis (but see the cautions in "Logistics" on page 11).

For all their wildness, awesome beauty, and stunning features, Yosemite and the High Sierra are startlingly close to major population

Upper and Lower Yosemite Falls

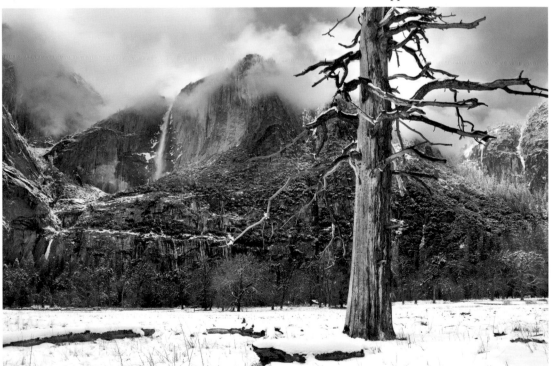

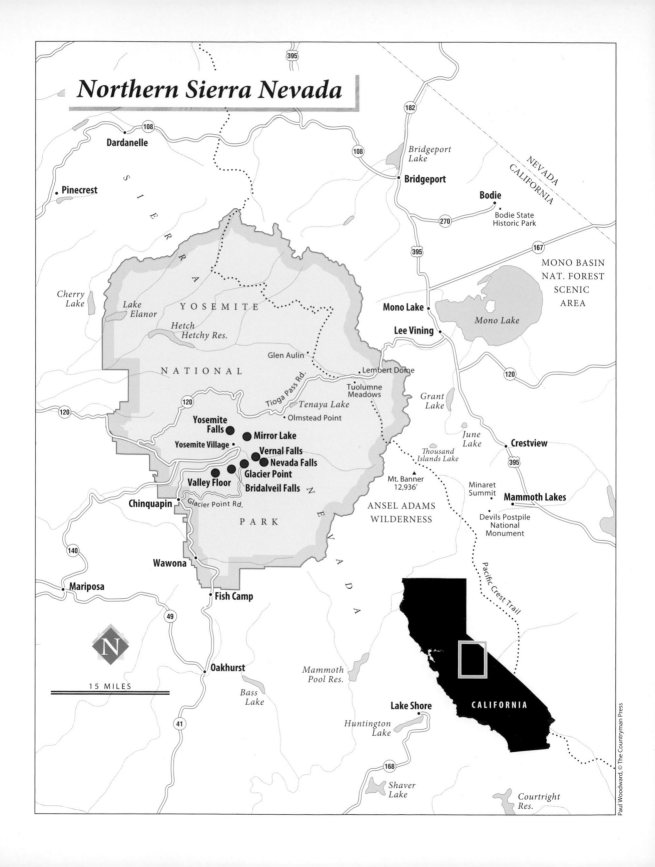

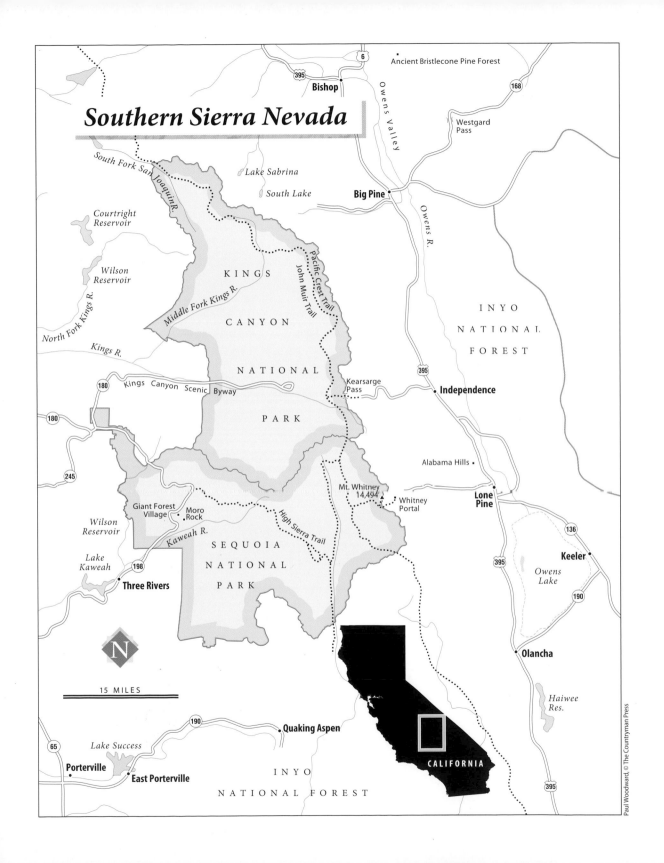

Southern Sierra Nevada

Ancient Bristlecone Pine Forest

Bishop

Owens Valley

Westgard Pass

South Fork San Joaquin R.

Lake Sabrina

South Lake

Big Pine

Courtright Reservoir

Owens R.

Wilson Reservoir

KINGS

Middle Fork Kings R.

Pacific Crest Trail

John Muir Trail

North Fork Kings R.

CANYON

INYO

NATIONAL

FOREST

Kings R.

NATIONAL

Kings Canyon Scenic Byway

Kearsarge Pass

Independence

PARK

Alabama Hills

Giant Forest Village

Moro Rock

Mt. Whitney 14,494'

Whitney Portal

Lone Pine

Wilson Reservoir

High Sierra Trail

Kaweah R.

SEQUOIA

NATIONAL

PARK

Keeler

Lake Kaweah

Owens Lake

Three Rivers

N

15 MILES

Haiwee Res.

Olancha

Quaking Aspen

Lake Success

CALIFORNIA

Porterville

INYO

East Porterville

NATIONAL FOREST

Paul Woodward © The Countryman Press

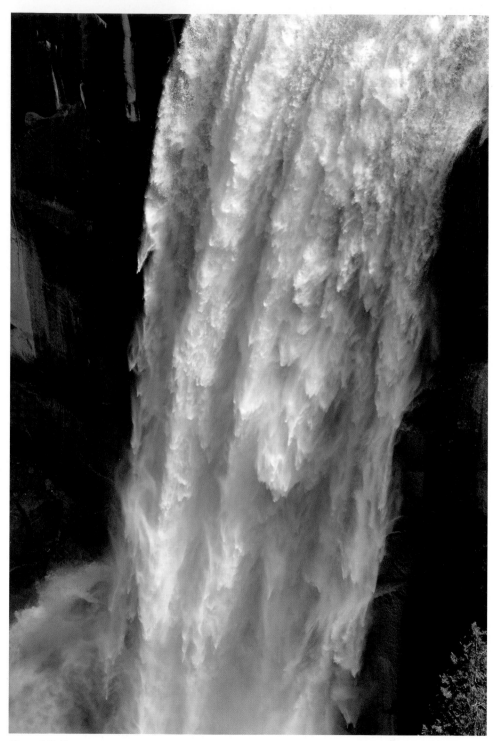

Vernal Falls

centers. Yosemite is (admittedly barely) within day-hiking range of San Francisco. If you get up at 4 AM in San Francisco, you can be hiking in Yosemite before noon if all goes well.

Yosemite is a bit farther from Los Angeles than San Francisco, perhaps a 9- or 10-hour drive away, but Los Angeles is closer to the eastern Sierra and to the southern parks, Kings Canyon and Sequoia.

Logistics

As noted, Yosemite and the Sierras are relatively close to San Francisco and Los Angeles. While public buses serve Yosemite Valley, most photographers will prefer to drive so they can be flexible about where they stop to photograph. However you get to Yosemite Valley, you should plan to park your car once you get there. The free Yosemite Valley shuttle bus is the best way (other than walking) to get around the valley floor. Taking the environmentally-friendly shuttle bus means that you won't be polluting the valley with your car exhaust (a potentially serious issue), and that you can concentrate on looking at the scenery rather than getting stuck in a traffic jam on the valley floor.

Trips to Yosemite and the Sierras are subject to the vagaries of mountain weather, and to the regulations of the California Highway Patrol (CHP) and the specific national park or forest you plan to visit. You'll find contact information in the appendixes (starting on page 87) if you have questions about current conditions, or about park or forest rules.

In winter months, you should know that you probably will be required to carry snow chains for your car. You can check with the CHP to verify details as they apply to your vehicle and your destination. If you are new to snow chains, you'll be glad to know that you can usually get assistance in putting them on and taking them off.

Summer is high season in Yosemite and the surrounding areas—although, as I've mentioned, summer is not necessarily the best season for photography. In the summer, campground or accommodation reservations are needed; plan ahead and don't visit without them.

Wilderness permits are required for any backcountry trip with an overnight stay.

Yosemite Valley and other Sierra jurisdictions are very serious about their bear regulations. These are intended to minimize inappropriate contact between bears and humans, which may result in the destruction of the bear. You should familiarize yourself with these regulations and comply with them by keeping your food out of your tent and car, and in bear-proof containers.

Photography in Yosemite Valley

Photographing Yosemite Valley has been one of my life's greatest joys, but of course it also has its challenges. If I had to sum up the problems with photography in Yosemite, it would be *too much*, *too big*, and *too many*: too much beauty, too much grandeur (these are problems we all should have!), too big in scale (if the entire vista won't fit in your composition, how do you crop it?), and too many people, photographers, and photographs already taken.

With the millions of people visiting Yosemite every year, photographers need to be especially careful. If you are interested in photographing the beauty of the wilderness, you have a special duty to help preserve it. Keep out of areas that are off-limits (likely the public is being kept out so the area can regenerate), and avoid trampling

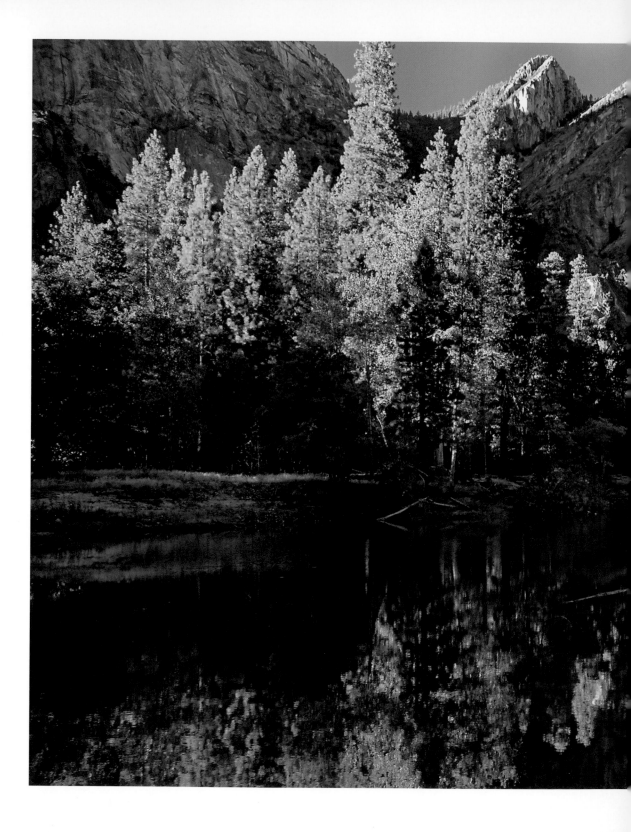

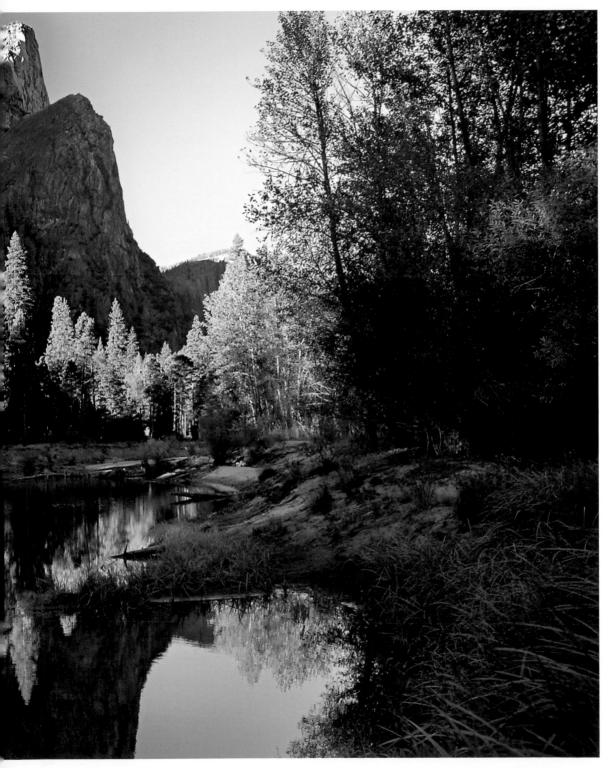

Three Brothers in autumn

meadows. Don't feed or harass wildlife, even in search of a great photo.

The dictum to "take nothing but photographs, leave nothing but footprints" is really, really true for photographers. Park regulations prohibit removing anything from Yosemite National Park, but even if it they didn't, as a photographer you should take special care to leave things the way you found them. It's OK to rearrange rocks, leaves, twigs and other composition elements, but try to put them back after you're finished with them.

There are several approaches to dealing with the crowds of photographers you will find in Yosemite at the most famous viewpoints. I've already suggested visiting Yosemite off-season as a great option. You might also make the effort to walk just a little bit off the roads. For example, I've been at Tunnel View at times when there have been scores of photographers pointing their lenses at a vista Ansel Adams made famous. Just a short walk up the Inspiration Point Trail, the view gets even better. And there are usually no other photographers.

The most important point is to work to develop your own vision. Don't go to Yosemite or the High Sierra in an effort to replicate work that has already been done. Instead, go as a photographer to have fun, be creative, and to return with imagery that is uniquely yours!

Equipment

It is well said that the photographer's eye is what makes a great photograph, not the photographer's equipment. In writing this book, I make no particular assumptions about the kind of camera or lenses you have, because I don't think equipment is what really matters. That said, it is important for you to consider your equipment in the context of limitations: what you can't do with your camera and photo equipment. By the way, I consider limitations as an essential component of photographic creativity: if I'm creatively stuck I often take a single lens, and give myself the assignment of doing as many wacky things as possible with that lens. In other words, an external limitation can inspire greater artistic freedom!

In writing this book, I assume that you are using a digital camera (although most of the content of this book would also apply to film photography).

Digital photographers need to take precautions to keep their equipment from getting too cold in the winter. If you have a digital SLR (Single Lens Reflex), you should be cautious about changing lenses in stormy or windswept conditions. (Dirt on the sensor grid is one of the biggest problems with dSLRs.)

Before you go into the field, you should do a back-of-the-envelope calculation of how much memory storage you are likely to need. If this goes beyond a reasonable number of memory cards, you'll probably want to carry either a "digital wallet" or a laptop computer. (A digital wallet is a hard drive connected to a device that can read memory cards and runs on a rechargeable battery.) You should formulate a strategy for recharging camera and digital wallet batteries—and recharge them every time you are near an electrical outlet.

Perhaps you are camping and do not have access to electricity for recharging your digital appliances. However, with a little ingenuity, you should be able to find an outlet in Yosemite Valley; the commons room at Curry Village is a good choice. Of course, in the High Sierra wilderness you won't find any electrical outlets!

A good tripod is an essential tool for every serious nature or landscape photographer. It is virtually impossible to take good pictures in low light conditions without one. Your choice

of tripod may be more important in the long run than your choice of camera (and the tripod is certainly likely to last longer).

Despite the expense, I'd suggest a tripod with carbon fiber legs. Carbon fiber is a strong, lightweight material that does not conduct temperature, a true lifesaver in outdoor photography in the winter.

On Photographing Mountains, Valleys, and Waterfalls

Photographing Yosemite and the High Sierra is about capturing mountains, valleys, and waterfalls. Well, OK; it's also about photographing sky, weather, clouds, grass, flowers, and trees. But you get the idea. We are basically talking about landscape and scenery, maybe with an occasional person or animal.

Many of the early photographers of Yosemite intentionally put a person (or people) into their photographs to create a sense of scale. It's hard to know how big and majestic Half Dome is without something (like a person standing on top) for comparison.

While it is a perfectly reasonable strategy to include people in your photographs to give your landscapes a sense of scale, I don't often do this. I like scale in my photographs to be mysterious, one of the elements that the viewer of the photograph may

need to decode from subtle clues, like a visual puzzle. You will have to make up your own mind about how to handle scale in your photographs of Yosemite, and whether you want to include people (there are certainly enough there if you do want them).

Photographing waterfalls is about capturing motion. As an experiment, try photographing a waterfall at a variety of shutter speeds between one second and 1/1000 of a second. It's easy to do this if you put your camera in

Half Dome in Mirror Lake

shutter-preferred mode, assuming that there is enough light at the faster end of this range. Of course, your camera should be tripod mounted for decent results at the slower end of this shutter-speed range.

When you look at your photos, you'll see that the moving water has been rendered very differently at the various shutter speeds. At the slowest speeds, the water appears solid, like some kind of slowly moving gelatin. At the fastest speeds, water seems frozen in mid-drop. Intermediate shutter speeds—say, 1/60

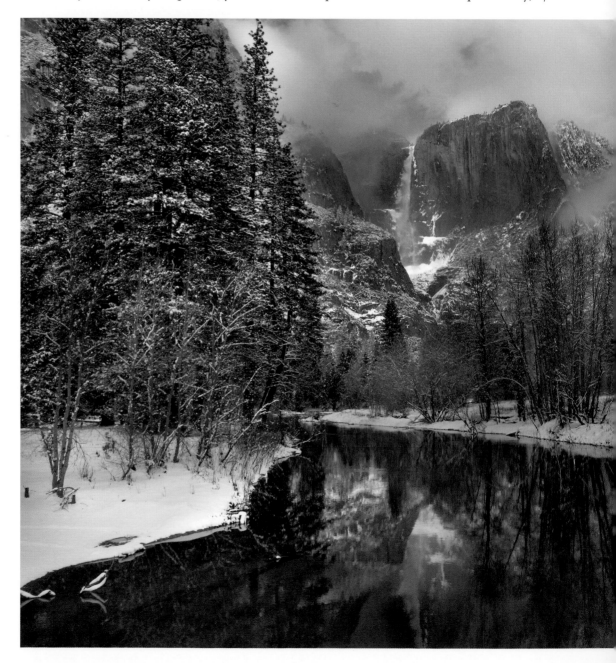

or 1/125 of a second—render water in a way that seems most natural to us, with motion and a slight blurring.

The point here is to be aware of the effect of these variations. Visualize the image you would like to capture because you will get very different results depending on your technical choices.

It's not unusual to see a photographer using a flash when aiming a camera at a vast vista, say the overlook at Glacier Point. It's easy to make fun of this kind of hardware gaffe: the poor fool of an automatic camera doesn't realize it's pointed out over a great void and can't possibly reach to the other side.

Actually, the camera tries to use its flash in response to two very real problems. One is that the overall scene is dark. The only cure for this is to use a tripod and make sure the camera is set an appropriate slow shutter speed. Another reason the flash goes off is that the image requires a wide range of exposures, from lights (in the sky and on the mountains) to darks (the valley). In its own poor, dumb way the automatic camera is trying to compensate for the darkness in the valley by filling in with its flash.

Obviously, however, fill flash doesn't work when the distances are big. The tripod-and-slow-shutter-speed technique isn't the answer either: if you expose for the valley, your mountains and sky will be overexposed.

However, if you have a camera that lets you expose RAW images, you'll be fine. (Remarks about RAW captures in this book apply, of course, only if your camera can do them; RAW is the format used by some digital cameras that preserves all available information.) Take any reasonable exposure. Better yet, bracket some exposures; that is, take several exposures, letting in less or more light around a given exposure by varying the aperture or shutter speed. Back at your computer, you can multiprocess a single RAW image to encompass an exposure for the valley and one for the mountains, combining the different RAW processed values using a program like Photoshop.

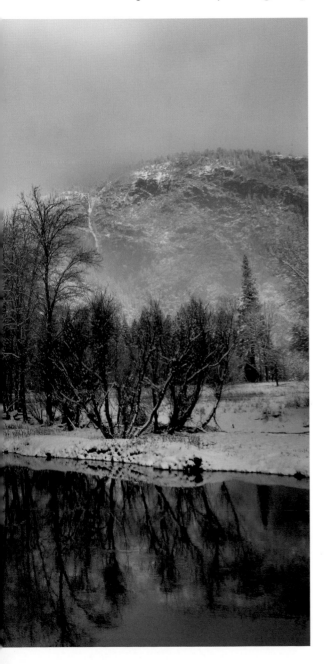

Yosemite Falls from Swinging Bridge

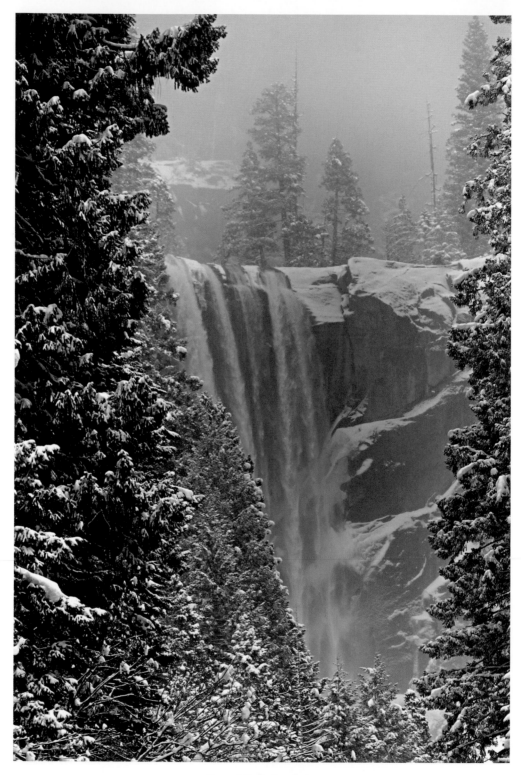

Vernal Falls in winter

I. Yosemite Valley

Valley Floor

The Classic Views

Everywhere you go in Yosemite you see something photogenic. It's hard to take a step in the valley without spotting something you want to photograph. For a photographer, it's like being a kid in a candy shop. Whether you are camping, staying in Curry Village, or at one of the lodges, it's likely that you will see something amazing simply in the process of getting up and going to breakfast.

Three California highways lead to Yosemite Valley: CA 41 from the south, CA 140 from Merced and the west, and CA 120 from the north.

Of these, CA 140 is probably the most direct, and is the approach that is lowest in elevation—so it is preferred in winter. However, CA 140 is often closed by mudslides in Merced Canyon, so you should check road conditions in advance (see "Trip Planning Resources" on page 87).

Whichever way you approach the valley, if it is your first time, you should keep your eyes

Approaching the entrance to Yosemite (CA 120)

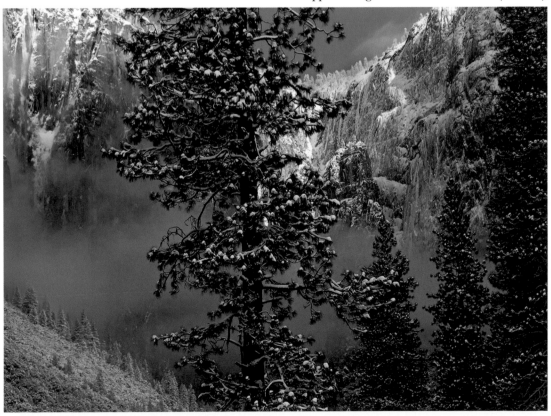

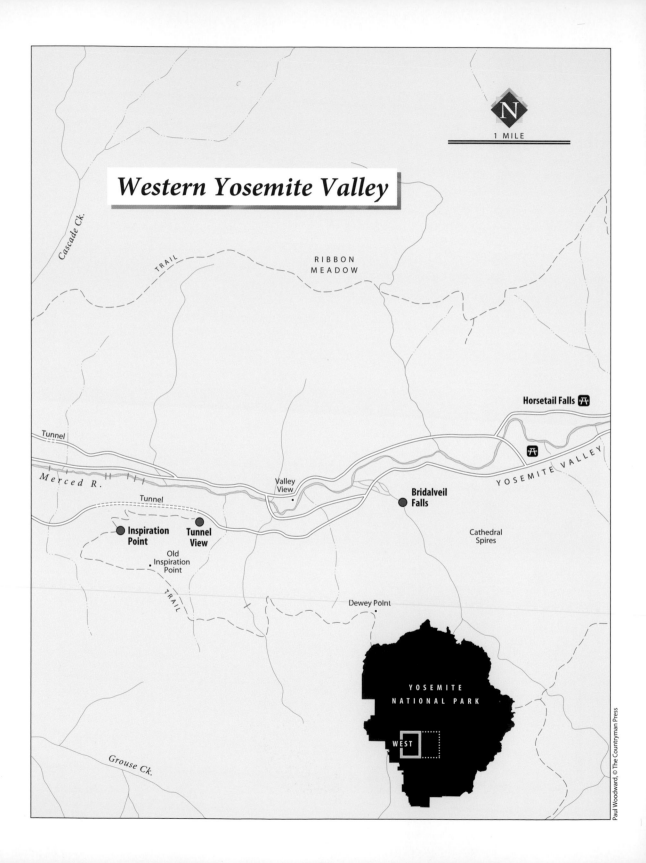

Western Yosemite Valley

N

1 MILE

Cascade Ck.

TRAIL

RIBBON
MEADOW

Horsetail Falls 🏕

Tunnel

Merced R.

Tunnel

Valley
View

YOSEMITE VALLEY

Bridalveil
Falls

● Inspiration
Point

● Tunnel
View

Old
Inspiration
Point

Cathedral
Spires

TRAIL

Dewey Point

YOSEMITE
NATIONAL PARK

WEST

Grouse Ck.

Paul Woodward, © The Countryman Press

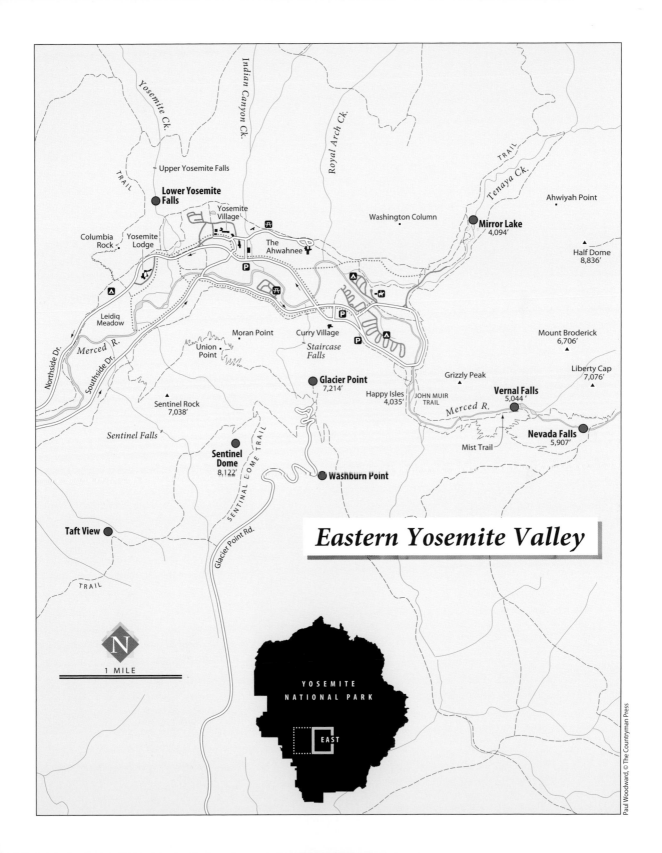

Yosemite Ck.

Indian Canyon Ck.

Royal Arch Ck.

TRAIL

Tenaya Ck.

~ Upper Yosemite Falls

**Lower Yosemite
Falls**

Yosemite
Village

Washington Column

Ahwiyah Point

Mirror Lake
4,094′

Columbia
Rock

Yosemite
Lodge

The Ahwahnee

Half Dome
8,836′

Leidiq
Meadow

Moran Point

Curry Village

*Staircase
Falls*

Mount Broderick
6,706′

Merced R.

Northside Dr.

Southside Dr.

Union
Point

Glacier Point
7,214′

Happy Isles
4,035′

Grizzly Peak

JOHN MUIR
TRAIL

Liberty Cap
7,076′

Vernal Falls
5,044 ′

Merced R.

Sentinel Rock
7,038′

Sentinel Falls

SENTINEL DOME TRAIL

**Sentinel
Dome**
8,122′

Mist Trail

Nevada Falls
5,907′

Washburn Point

Eastern Yosemite Valley

Glacier Point Rd.

Taft View

TRAIL

N

1 MILE

YOSEMITE
NATIONAL PARK

EAST

Paul Woodward, © The Countryman Press

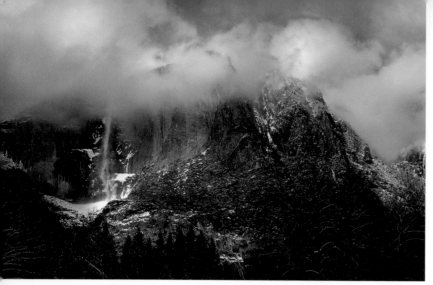
Upper Yosemite Falls

vistas of the towering crags and waterfalls above.

You can make this tour of the valley by foot, shuttle bus, or in your car (or combine these modes of transportation). In any case, you should allow at least half a day to a full day simply to explore the valley and to get a good idea of the best photographic opportunities.

Landscape photographers are well aware that the best times of day for photography are early morning and early evening: before, during, and after sunrise

open. The approach to Yosemite Valley is the visual experience of a lifetime. By absorbing the topography you orient yourself for photography within Yosemite.

As you come around the bend from the southern entrance on CA 41, Yosemite Valley is completely hidden until you pass through a tunnel. Then the valley is laid out before you. This is the famous Tunnel View. Take it slow through the tunnel; cross-traffic is busy at its end. Pull off and absorb the view, even if you plan to come back to Tunnel View at sunset for photography.

Here you can see how Yosemite Valley was carved from vast glaciated cliffs by the Merced River. The river takes a turn and vanishes behind the wall made by Glacier Point just in front of Half Dome. On the other (northwestern) side of Half Dome a tributary valley is formed by Tenaya Creek and Mirror Lake.

A good first step to orient yourself for photography in Yosemite Valley, after you've checked in and secured your lodgings or campsite, is to tour the valley floor. Many wonderful photographs can be taken without even leaving the valley floor, ranging from views of glades along the Merced River to

and sunset. This poses a special photographic challenge in Yosemite Valley, which lies deep between spectacular formations of granite. These cliffs are aglow with beautiful light at the beginning of the day, yet the valley floor will be in shadow for several more hours. At the end of the day, the same conditions apply. Depending on the time of year, the valley floor will go into deep shadow by late afternoon, while the cliffs and waterfalls are bright with light for several more hours. The best light of all on Half Dome and the other walls of the valley won't appear until it is almost night, and the valley itself is deep in darkness.

This play of light and shadow in Yosemite Valley and along the faces of its mighty walls and waterfalls is great fun to watch. From a photographer's point of view, the differential between glowing cliffs and darkening valley presents a technical challenge because of the large range in contrast. Pre-digitally, the best solution would have been to use a split or gradient neutral density filter on the lens to adjust the contrast, so that one exposure would work for the entire contrast range.

With digital cameras, you have some options that are more effective than using on-

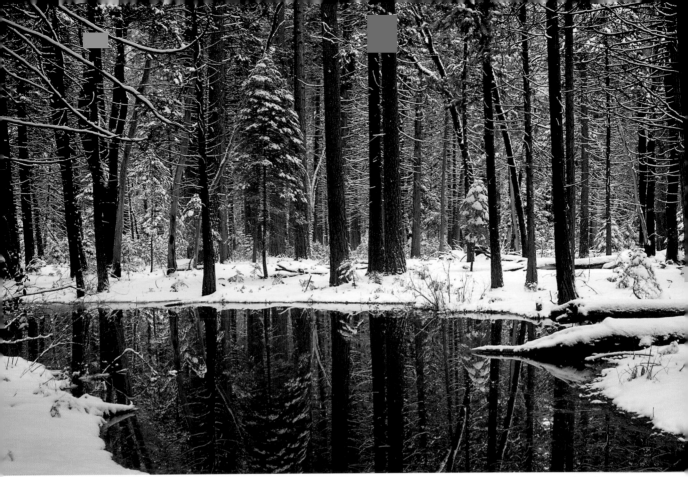

Valley floor in winter

camera filters. A single RAW capture includes a wide range of possible exposures, which you can combine to create a final version that has a viable range of contrast across the lights and darks that you'll find in the early evening in Yosemite. It's also possible to shoot multiple exposures and have them automatically pasted together to form one HDR (High Dynamic Range) image with a complete contrast range from the darkest values of the darkest HDR capture to the lightest values in the lightest HDR capture.

However, you will need some preparation: if you propose to multiprocess your RAW images. Obviously you must capture them in RAW in the first place rather than as JPEGs. Check your camera manual to learn how to make RAW captures. You also need to run a program capable of processing RAW images such as Photoshop.

If you plan to merge images to create a HDR composite image, for example including Half Dome at sunset and a valley vista, then you need to make sure that each of the images in the composite is framed in exactly the same way. That means you'll need a tripod when you take the photos, but using a tripod is almost always a good idea in landscape photography.

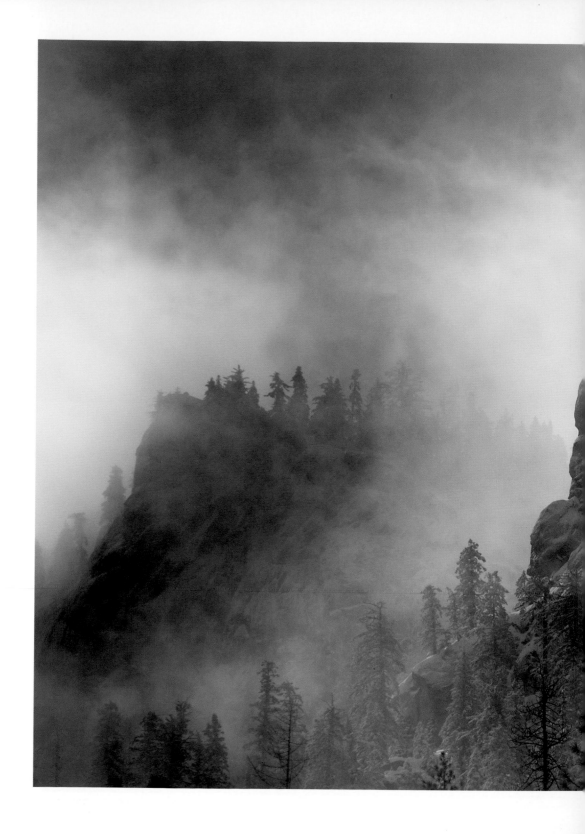

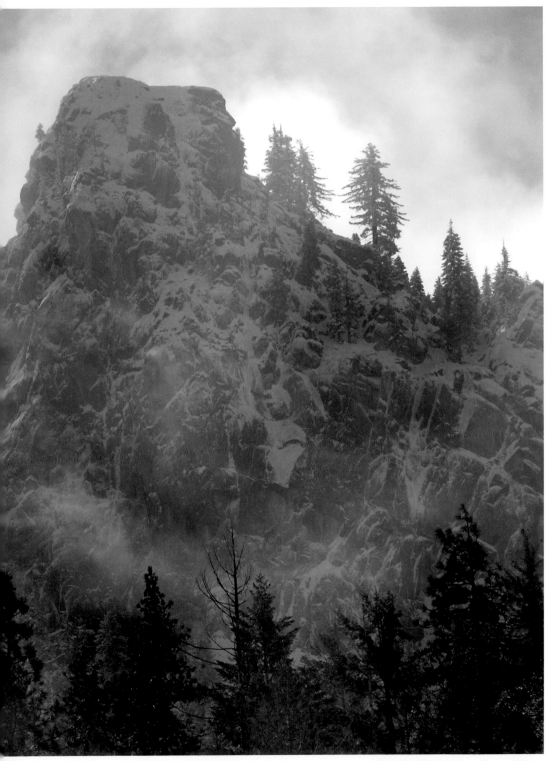

Stanford Point from Tunnel View

Yosemite Falls

North America's Highest Waterfall

Yosemite Falls is actually three waterfalls, of which two, Upper Yosemite Falls, 1,430 feet, and Lower Yosemite Falls, 320 feet, are visible from the valley floor, but the Middle Falls (675 feet) is not. Upper Yosemite Falls is the waterfall with the greatest vertical drop in North America—another one of Yosemite and the Sierras' superlatives.

You can see, and photograph, Yosemite Falls from many spots on the valley floor. Besides the trail and vista point near Lower Yosemite Falls, good sites for photographing Yosemite Falls from the valley floor include Sentinel Bridge, Swinging Bridge, and Leidig Meadow.

Oddly enough, some of the best distant views of Yosemite Falls are from the center of

Directions: Get off at shuttle bus stop number 6 for Lower Yosemite Falls.

The Hike: A short, ½-mile loop to the base of Lower Yosemite Falls; a strenuous 7-mile (roundtrip) hike to the Yosemite Point vista above Upper Yosemite Falls.

Natural Hazards: Be careful anywhere near the banks of Yosemite Creek. Take great care near the edge on the Upper Yosemite Falls Trail. Stay well back from Yosemite Creek where it plunges over the falls as the rocks are extremely slippery, and a slip would be fatal.

Area: Yosemite Valley, Yosemite National Park.

Yosemite Village, the commercial hub of Yosemite Valley, and Curry Village (popular tent and cabin lodgings). The challenge from these positions is composing photographs in a way that excludes the aspects of civilization (assuming this is your goal). Some extremely interest-

Upper and Lower Yosemite Falls

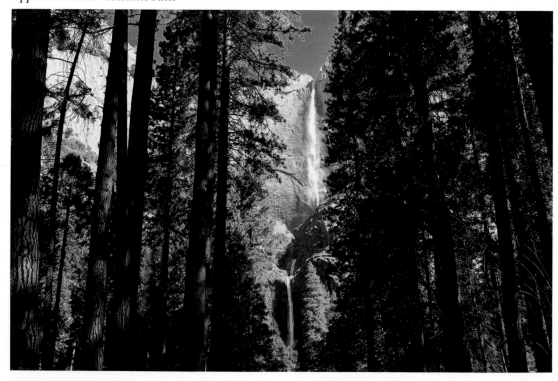

ing views of Yosemite Falls are obliquely across the valley from the Curry Village parking lot.

Of course, the view gets more exciting as you get closer to Yosemite Falls. It's easy to get close to the bottom of Lower Yosemite Falls, but it takes considerably more effort to approach the Upper Falls.

To get to the falls, take the shuttle bus to stop number 6. Alternatively, from Yosemite Lodge, follow the signs toward Yosemite Falls. A paved path crosses the road and takes you to the base of the Lower Falls. If you park in the day-use parking facility near Yosemite Village, you can follow the signs to walk to Yosemite Falls. Limited parking is also available along the road near the Yosemite Falls shuttle bus stop.

From the observation point at the base of the trail to the foot of Yosemite Falls, you can scramble over the rocks to get closer to the falls. But this should only be done with great care as the rocks are extremely slippery, and the water cold and treacherous.

The best time to photograph Yosemite Falls is probably March through early June, when water from snowmelt is at its highest. However, Yosemite Falls is also spectacular in the winter when snow and ice form unique patterns next to the falling water.

Most photographers will find the observation point near the Lower Yosemite Falls easy to get to and inspiring. Those who are ready for a more strenuous experience will find the trek to the Upper Falls very rewarding.

To find the trail to Upper Yosemite Falls, start at the shuttle bus stop for the Lower Falls Trail. Follow the path to the east past the top of Camp 4, a walk-in campground particularly frequented by climbers. In about ½ mile you'll come to the junction with the Yosemite Falls Trail.

The trail is pretty tiring, starting with switchback after switchback, and gaining almost 3,000 vertical feet. Considering the dif-

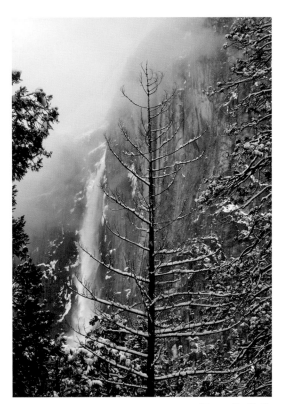

Yosemite Falls

ficulty, it is very heavily used, perhaps because Yosemite Falls is the highest waterfall on the continent.

As noted, it is best to plan to photograph Yosemite Falls early in the season because by late summer the water has slowed to a trickle. The good news is that the Yosemite Falls Trail hugs a cliff with southern exposure, and so tends to clear earlier than most other valley trails.

After about a mile of switchbacks, the trail reaches Columbia Rock, a great place to photograph vistas of Yosemite Valley. However, if you want to photograph from Columbia Rock in the late afternoon when the light is best, you may need to descend after dark, so be sure to bring a flashlight (a caution that applies even more so to destinations farther along the Yosemite Falls Trail).

In another ½ mile, the trail approaches

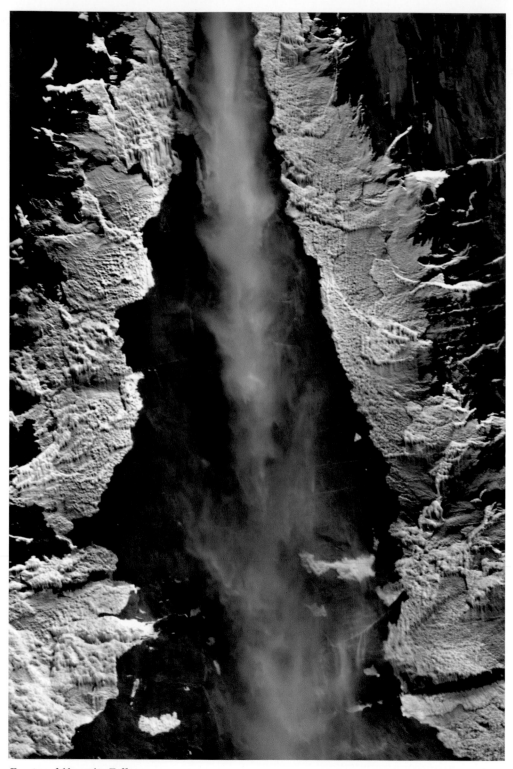

Frost and Yosemite Falls

Lower Yosemite Falls. In this area, be careful to keep photographic gear dry, be wary of slippery rocks, and hope for rainbows.

Above Lower Yosemite Falls is another steep set of switchbacks continuing up to the rim of the valley. Once you gain the rim, you cross Yosemite Creek on a bridge and head for the vista at Yosemite Point.

Whether you photograph Yosemite Falls from up close and personal along the Yosemite Falls Trail, or from a distance in the Yosemite Valley, you'll need to consider your strategy for making memorable images of this much-photographed waterfall.

Depending on conditions (mostly the time of day and the position of the sun), you can silhouette the waterfall with the sun in the background. Usually, this means that you'll want to "freeze" the motion of the falling water with a shutter speed of 1/500 of a second (or faster).

On the topic of shutter speed, if you don't want to freeze moving water (this is the most apparently lifelike way to treat water), you can choose a slow shutter speed (longer than ¼ of a second) to produce an image of water with an almost solid look. Intermediate shutter speeds (1/30–1/125 of a second) produce both sharpness and a mild blur, which may be the most pleasing depending on the circumstances. (For more information, turn to page 15 and see "On Photographing Mountains, Valleys, and Waterfalls.")

Consider, also, whether you are primarily interested in Yosemite Falls or its background. Close up, in winter, frost frames Yosemite Falls. From farther away, Yosemite Falls creates a great contrast to the lushness of Yosemite in the spring.

Yosemite Falls from Cook Meadow

Bridalveil Falls

Pohono, Spirit of the Wind

The indigenous peoples who lived in Yosemite called Bridalveil Falls "Pohono," which means "Spirit of the Wind." Indeed, of all the major Yosemite Valley waterfalls, Bridalveil is the most subject to the caprices of the wind. Depending on wind strength and direction and seasonal factors, Bridalveil Falls can be blown at right angles or even seem like a gentle (if gargantuan) shower. The best photos of Bridalveil Falls show its playful relationship with the wind.

Besides the observation area directly below Bridalveil Falls, good views and photographic opportunities are at Tunnel View and the Inspiration Point Trail, and across the valley from Northside Drive and Bridalveil Meadows.

A short, paved trail (about ¼ mile) leads along Bridalveil Creek from the parking lot near the junction of CA 41 and the North Yosemite Valley drive to the observation point at the base of the falls. The last 200 feet of this trail can be

Directions: From points within Yosemite Valley, drive toward the park exits following the Northside Drive along the Merced River. Follow signs for CA 41, looping back over the Merced River near Bridalveil Meadows onto the Southside Drive as if you were returning to the valley. Park in the Bridalveil Falls parking lot. If you are taking the southern route (CA 41) into the valley, you'll pass the Bridalveil Falls parking lot on your way into Yosemite Valley.

The Hike: A ¼-mile paved path to the base of Bridalveil Falls.

Natural Hazards: Depending on the time of year, the path can be extremely slick with ice. If a strong wind is blowing, water can fall heavily on the path, a potential danger to cameras.

Area: Yosemite Valley, Yosemite National Park.

covered in ice, with approach possible only by dragging yourself up the handrails.

Bridalveil Falls is at its best from March through May, when it runs strong and full. Be very careful, however, in approaching the falls at this time of year. Ice is not the only hazard. Bridalveil Creek can also run high, and the wind around Bridalveil Falls can be very strong (as witnessed by the name Pohono). All this means that you need to watch out for your own safety, and also be cautious with your camera gear. Up close, the area under Bridalveil Falls can remind you of a tropical storm—just as wet, but not as warm.

Bridalveil Creek in spring

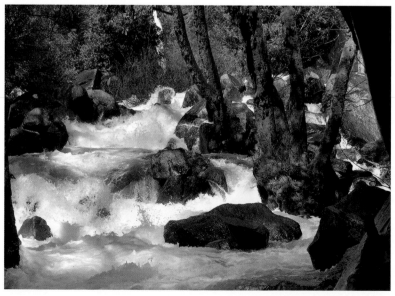

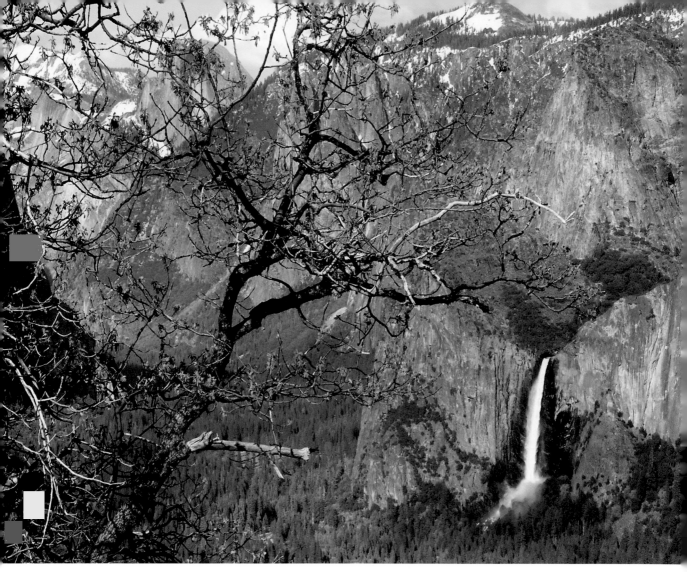

Bridalveil Falls from Inspiration Point Trail

Plan to bring some kind of protection for your camera if you will be photographing from this area because the spray can damage an unprotected camera out for even a single exposure. Several companies make waterproof nylon "raincoats" that fit a variety of digital cameras, or you can use a shower cap or a plastic bag with a thick rubber band around the lens.

It's really hard to get much of a feeling for Bridalveil Falls at close range in the midst of the maelstrom it creates. You are probably better off—and more likely to capture the wind-borne spirit of this magnificent and poetic waterfall—choosing a distant vantage point like that from Tunnel View, the Inspiration Point Trail, or from the far side of the valley.

Vernal Falls and the Mist Trail

Always a Rainbow

The popular and well-traveled path to the bridge below Vernal Falls is also the start of the John Muir Trail, which proceeds up to Tuolumne Meadows and then south to Mount Whitney and Trail Crest some 200 miles later.

This initial segment of the Muir Trail is often crowded; however, the wilderness vistas are well worth battling the crowds. Below, the Merced River churns in its gorge. Particularly worth photographing: the view across Yosemite Valley of Upper Yosemite Falls.

With one final bend, the trail ascends a last rise and then descends to the bridge over Merced River with spectacular views of Vernal Falls. The Merced River falls (Vernal Falls and Nevada Falls) are the only major four-season waterfalls in Yosemite Valley. If you visit in September or early October, Vernal and Nevada Falls will still be running even though Bridalveil Falls and Yosemite Falls are dry.

While the view of Vernal Falls from the bridge is spectacular, the bridge tends to vibrate, so it may not lend itself to the use of a tripod. Weather and water conditions permitting (watch out for slippery footing and high water), you can make your way upstream

Directions: Get off the shuttle bus at Happy Isle (stop number 16). Cross the Merced River on the bridge in front of the bus stop. The broad, well-marked trail proceeds up and to the right along the far side of the Merced River.

The Hike: A steep, partially paved trail of about 1 mile will bring you to the bridge below Vernal Falls. From the lower bridge, it is almost 2 miles farther via the Mist Trail to the top of Vernal Falls.

Natural Hazards: The Mist Trail consists of hundreds of very slippery rock-hewn steps. You should take great care on this route. During wetter times of year, it is impossible to avoid getting drenched on the Mist Trail; take precautions to protect photographic gear. Don't attempt to swim in the Silver Apron above Vernal Falls, as there is a risk of being swept over the falls. There are a number of unfenced massive drops above Vernal Falls.

Area: Yosemite Valley, Yosemite National Park.

Ice on the Merced River

alongside the Merced River on the far side of the bridge following the Mist Trail to find a better spot for tripod photography.

If you are proceeding up from the Vernal Falls bridge, you'll come to an almost immediate trail junction. The Mist Trail follows alongside the banks of the Merced River, while the main John Muir Trail switchbacks to the right and around. The two routes come together again above Nevada Falls. Note that the Mist Trail is subject to seasonal closures and is almost always closed in winter months.

The Mist Trail offers a number of classic spots for photography of Vernal Falls from along the Merced River. Rounding a bend, the trail starts climbing a series of steep, usually wet steps beside Vernal Falls and the Emerald Pool.

No matter what time of year you climb the Mist Trail, you'll almost certainly encounter

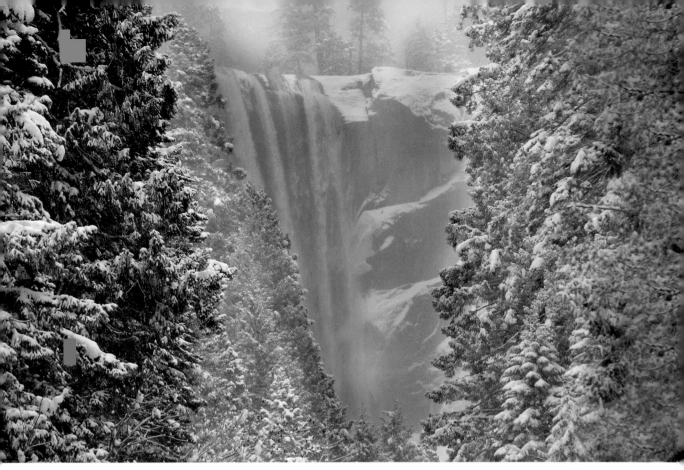

Vernal Falls in winter

rainbows to photograph. With the exception of the driest months, you'll also get very wet once you start up the stairs.

Getting wet on a nice, warm sunny day in the mountains is not usually a major issue. However, it does present a logistical challenge for photographers carrying equipment. If you bring your camera in a waterproof case and never take it out, it won't get wet, but neither will you get any photographs.

You do need to be cautious about exposing expensive electronics to massive quantities of moisture. I recommend a photographer's back-pack that is equipped with an integral water-proof raincoat.

If your camera backpack or your back

doesn't have a rainproof layer, you should plan to add one (a plastic trash bag will work perfectly well).

When you do take your camera out, be careful. Several spots along the Mist Trail provide some shelter. Be sure you have something to protect your camera when it is out of the waterproof container. You can use a specially made camera "raincoat" for this or (once again) a plastic bag. Some photographers swear by shower caps for this purpose, with the camera lens poking out the elasticized end.

When you reach the top of Vernal Falls, you'll probably be both dripping wet and very happy, because the Mist Trail is one of the world's best locations for capturing rainbows.

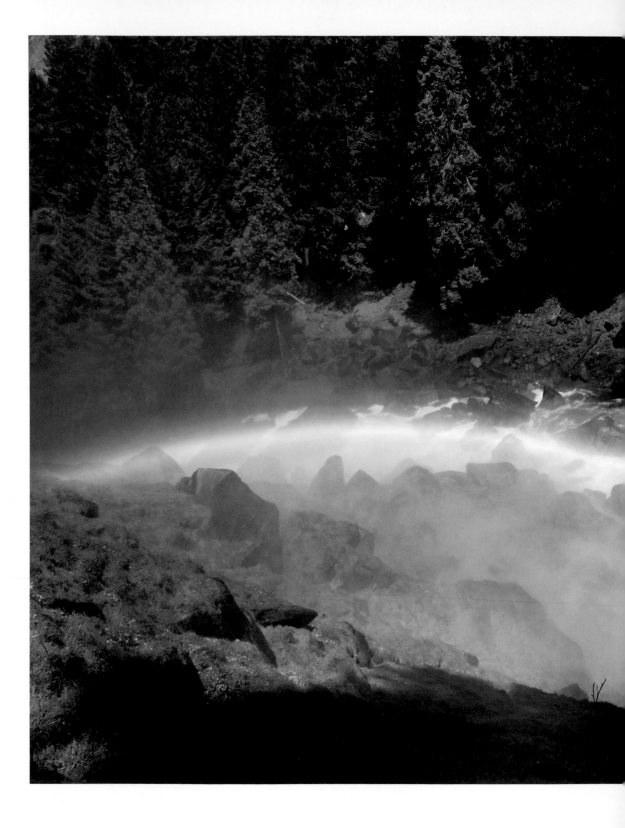

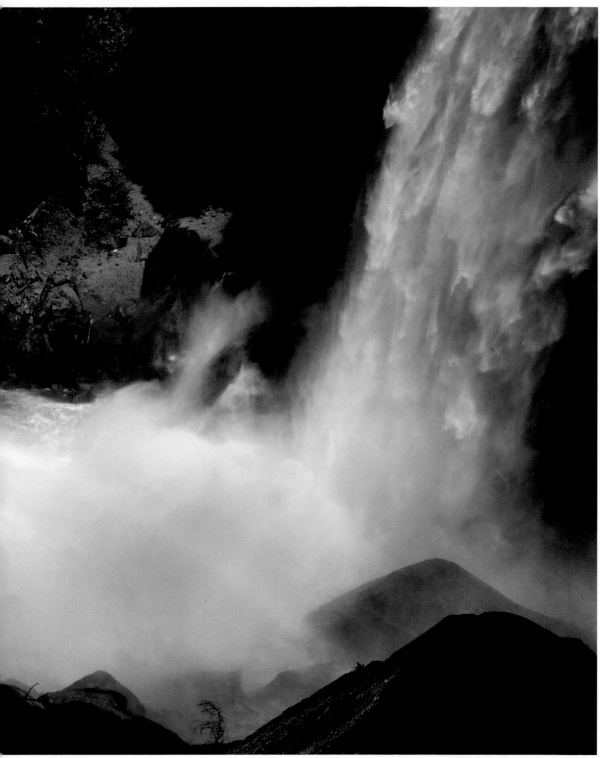

Rainbow along the Mist Trail

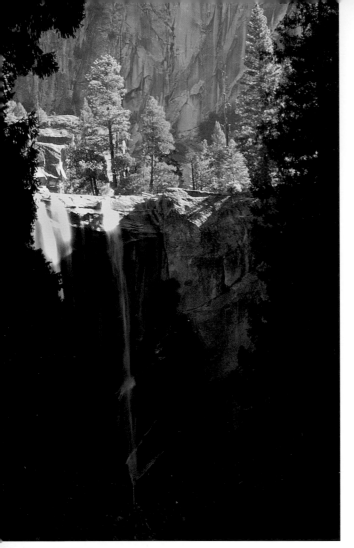

Vernal Falls in autumn

The observation deck at the top of Vernal Falls is well fenced on the side the falls goes over (the same side the trail follows). You should be able to position your camera both under and over the fence for good views down the falls. Note that in the other direction along the Merced River, along the Silver Apron, there is no fencing. Be extremely careful not to slip and get carried over the falls.

From the observation area at the top of Vernal Falls, you can make your way to a lesser known—but absolutely spectacular—spot for photographing Vernal Falls from slightly above.

Follow the trail alongside the Silver Apron and Emerald Pool as though you were going toward Nevada Falls. Instead of crossing the bridge over the Merced, take the cutoff trail marked toward the John Muir Trail (and back to the valley floor).

About ¼ mile up a series of switchbacks you'll come to a very short side path to the right that leads to an overlook across the Merced Canyon. This is one of the best views of Vernal Falls, but be extremely careful because it is unfenced and drops more than 1,000 feet straight down.

A great part of the fun of photographing Vernal Falls is photographing rainbows, so for best results you should know a bit about how rainbows work. As you probably know, a rainbow is an arc created by refractions on falling water drops. In fact, this rainbow arc represents a portion of a complete circle, with the rest of the circle underground from the viewpoint of someone at ground level.

Double rainbows, which can often be captured at Vernal Falls, consist of a lighter arc of refracted colors (of about 51 degrees) within the primary rainbow arc (usually about 42 degrees).

Rainbows are brightest when the sun is behind you because the rainbow forms a circle around the point that is directly opposite the sun. This point needs to be high enough to let the arc of the rainbow form. The geometry generally favors early morning or late afternoon as the best time for rainbows. In the case of Vernal Falls, however, the topography and atmospheric conditions create a rainbow most of the time, with a preference for midmorning when the sun has cleared the Merced Canyon walls.

Several factors that are out of the photographer's control change the colors in a rainbow. These factors include the color temperature of the ambient light. For example, near sunset

the light is warmer and redder, and so are any rainbows. Larger water drops also favor more vivid rainbows, and probably the prevailing weather conditions at Vernal Falls do cause the creation of larger than normal water drops. Finally, a dark background (like that presented by the igneous cliff under Vernal Falls) tends to create apparently brighter rainbows.

A recommended accessory for photograph- ing rainbows is a circular polarizing filter. The effect produced by this filter is one of the few that can't be duplicated with digital post- processing. A polarizer boosts color saturation in reflections and in water; since a rainbow consists of myriad water drops, a polarizer will amplify the extent and saturation of rainbows in most conditions. So pack a polarizer for your hike up the Mist Trail!

Looking down Vernal Falls at the Mist Trail

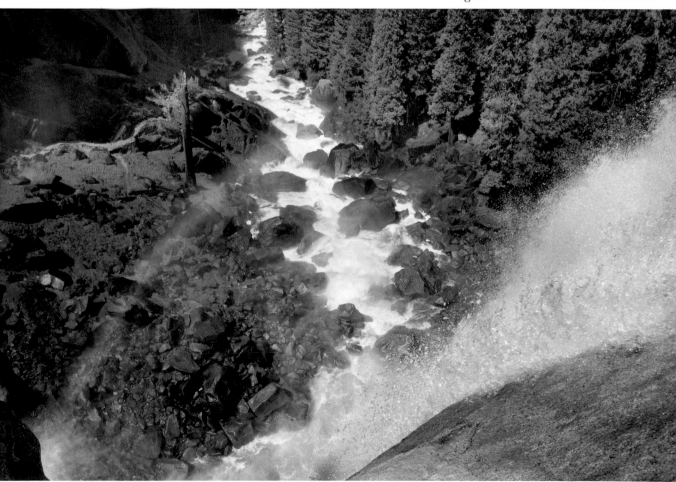

Nevada Falls

Mighty Water Flowing

Directions: From the bridge below Vernal Falls, either take the Mist Trail to the top of Vernal Falls and proceed several more miles to the top of Nevada Falls, or proceed up the John Muir Trail to the top of Nevada Falls.

The Hike: A roundtrip loop of about 8 miles, going up via the Mist Trail and returning via the Muir Trail.

Natural Hazards: Be careful near the waterfalls and around various unprotected major drops.

Area: Yosemite Valley, Yosemite National Park.

From the top of Vernal Falls, proceed alongside the Silver Apron, and pick up the trail when it crosses the Merced River on a massive bridge. The trail continues up the valley under the stony rock face of Liberty Cap. Depending on the season, this is an excellent area for wildflower and wildlife photography.

As you approach the base of Nevada Falls at the head of the valley, the roar of the falls and mist from its spray fills the air when the wind is right.

The trail switchbacks up between Liberty Cap and Nevada Falls, meeting the John Muir Trail at a point about ¼ mile beyond the top of the Nevada Falls. From here, proceed back down the Muir Trail to the bridge above the falls. Some of the best photography of Nevada Falls is from an observation area (only partially fenced, so take extreme care) reached by a side path just before you get to the bridge.

From the top of Nevada Falls, you can proceed along the John Muir Trail to Little Yosemite Valley and Half Dome. Note that you need a wilderness permit for any overnight camping, and you should also inquire about conditions and obtain permission before taking the route up the back of Half Dome.

Assuming that you are looping back to the Vernal Bridge crossing and Happy Isles via the John Muir Trail, look for photographic opportunities as the trail heads around the side of the valley. Here, the trail is roughly level with Nevada Falls, and you can point your lens back at the full vertical elevation of the falls. The striations in the rock, particularly when they are wet from high spring runoff, make for great photographs. Just watch your footing when you take these photos; it's a long way down!

Nevada Falls in spring

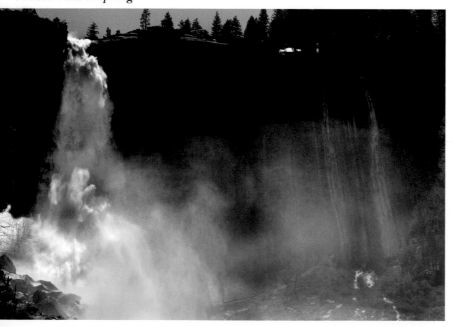

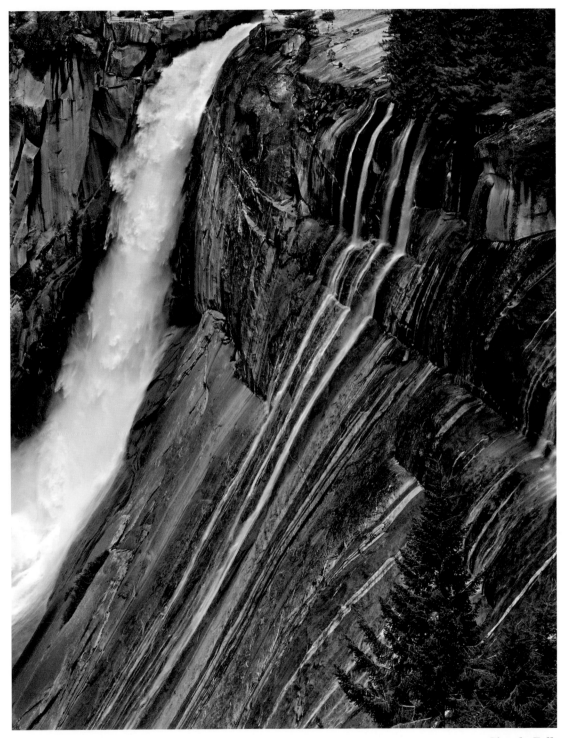

Nevada Falls

Mirror Lake

Seasonal Reflections

Directions: Get off the Yosemite Valley shuttle bus at stop number 17. Follow the signs to Mirror Lake.

The Hike: One mile each way on a gently sloping paved road (closed to cars but open to bicycles). Further walking as needed for photography.

Natural Hazards: None.

Area: Yosemite Valley, Yosemite National Park.

Mirror Lake lies at the end of a gently sloping paved road a mile from the shuttle bus stop on the Yosemite Valley floor. This road is closed to motorized traffic, so the walk is extremely pleasant. The only thing wrong with this picture is that for most of the year Mirror Lake is no lake at all. Depending on the year, unless you visit Mirror Lake in late winter or early spring, you'll find a sandy lake bottom rather than a lake.

Set in the spectacular valley formed by Tenaya Creek behind Half Dome, Mirror Lake is part of the "other" fork at the end of Yosemite Valley; the route alongside the Merced River up Vernal and Nevada Falls is better known. But the shortest way to hike up to the Tioga Road leads past Mirror Lake and up Tenaya Canyon to join the Tioga Pass Road at Olmsted Point. (If you are considering a wilderness trek such as the climb out of Yosemite Valley, be sure to take proper precautions, bring good maps, and be aware that overnight camping requires a wilderness permit.)

In the early years of Yosemite tourism, when Albert Bierstadt painted heroic vistas of the valley and Eadweard Muybridge and Carleton Watkins laboriously toted their plate-film cameras

Skim ice on Mirror Lake

on Yosemite's trails, Mirror Lake was a prime destination. Following a number of extremely wet seasons, the lake was wet through the summer, and entrepreneurs helped to make sure that the lake remained year-round by constructing a wooden dam. A grand Victorian hotel was built, with oompah-pah bands and dancing on the great terrace in the summer. In the winter, there was ice skating on Mirror Lake.

Today, nothing remains of all the bustle except the memories. Since the 1970s, the National Park Service has allowed Mirror Lake to revert to its natural state: a lake from late winter to early spring; otherwise the slowly meandering Tenaya Creek with occasional pools and a sandy bank.

If you do visit Mirror Lake at a time of year in which its waters reflect Half Dome and the crags of upper Tenaya Canyon, you should come prepared to photograph reflections in the water. Ideally, this means using a tripod and planning different exposures of water and landscape so that they can be combined in post-processing.

In addition, a circular polarizer is an excellent aid to photographing reflections. The polarizer screws on the end of your lens using the filter threads, and can then be rotated 360 degrees. Depending on the rotation, and direction of the light, reflections in water are greatly amplified.

You can expect to photograph a bona fide lake with reflections of Half Dome and the

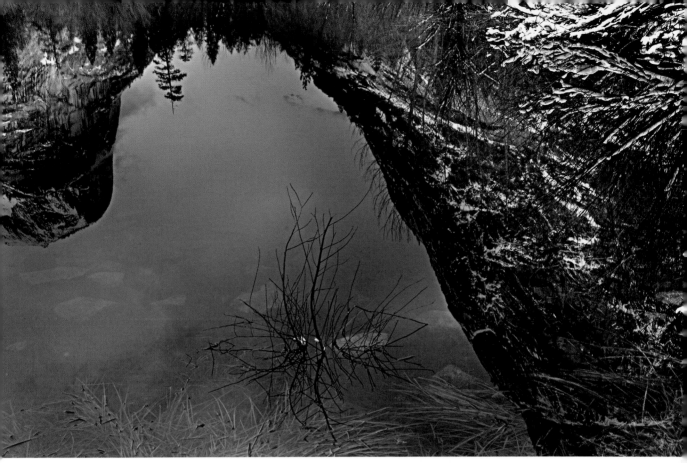

Mirror Lake

peaks that line Tenaya Canyon February through mid-May. Toward the beginning of this period, the water will be lined with ice and snow. By May (particularly in years with heavy snow runoff) the banks of the lake will be lined with green. All other times of year, expect a dry and sandy lake bottom.

While the Mirror Lake area is not so spectacular without water, it is easy to navigate the area on foot when it is dry. You'll also be able to photograph from some otherwise inaccessible viewpoints along the bank of Tenaya Creek. So the disappearance of the lake is not entirely negative from a photographer's perspective.

Once at Mirror Lake, you may be tempted to explore up Tenaya Canyon past the rugged Watkins Pinnacles. This is spectacular scenery, with a fairly easy trek of about 10 miles up to the Tioga Pass Road (CA 120) at Olmsted Point (see pages 57–58 for more information about the Tioga Pass Road and Olmsted Point). If the logistics are possible (for example, if you are traveling with a party who can drop you off and pick you up), you might well consider a one-way hike *down* into the valley along this route.

However, be aware that hiking in Tenaya Canyon itself is discouraged by the Park Service, which considers the area extremely dangerous because of deceptive and steep drop-offs. No trail routes go through this canyon. If you do hike up from Mirror Lake, note where the trail crosses Tenaya Creek on a bridge and ascends up and away from the canyon. You should plan to avoid Tenaya Canyon by following the trail, or returning to Mirror Lake.

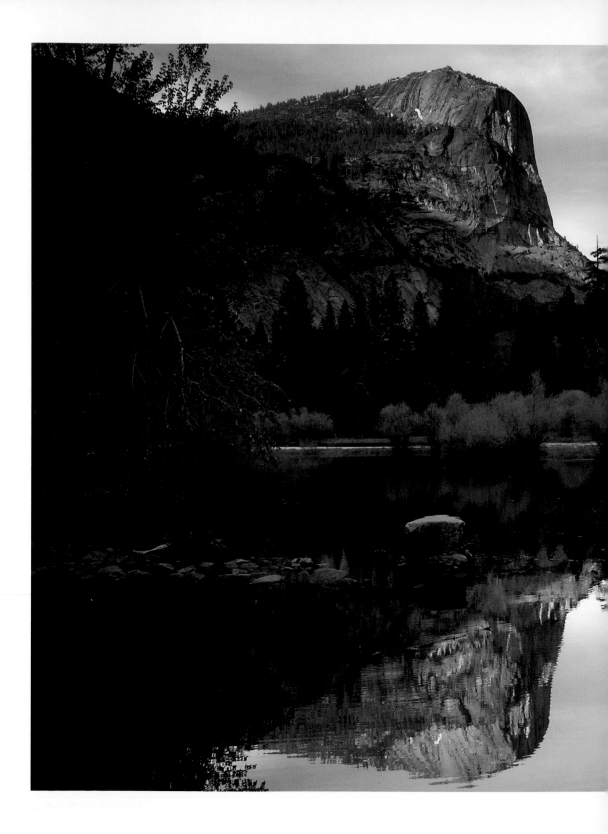

Mirror Lake in spring

Tunnel View and Inspiration Point

Noble Panoramas and Shifting Storms

Yosemite Valley is probably most photogenic as storm clouds mass, or as the storm lifts—and there are few better places to photograph a clearing storm over Yosemite in the afternoon than Tunnel View. In winter, when storms are most dramatic, the panorama from Tunnel View is particularly extravagant. (Note: You should plan to spend the night within Yosemite Valley if you are photographing storms in the afternoon at Tunnel View.)

As you come up CA 41 from Bridalveil Falls and Yosemite Valley, there are two parking lots at Tunnel View. Most people use the right-hand parking lot, where the vista point is.

Directions: Park in the Tunnel View parking lot on the southern approach to Yosemite Valley (CA 41). You'll find the trail to Inspiration Point across the highway at the edge of the parking lot facing the mountain.

The Hike: A classic view of Yosemite Valley is right from the parking lot. The trail up to Inspiration Point is ½ mile.

Natural Hazards: Watch for tricky traffic conditions, as the popular Tunnel View parking lot is next to the entrance and exit from the long tunnel on CA 41. The initial stretch on the Inspiration Point trail is quite steep, and can be slippery.

Area: Yosemite Valley, Yosemite National Park.

Bridalveil Falls from Inspiration Point Trail

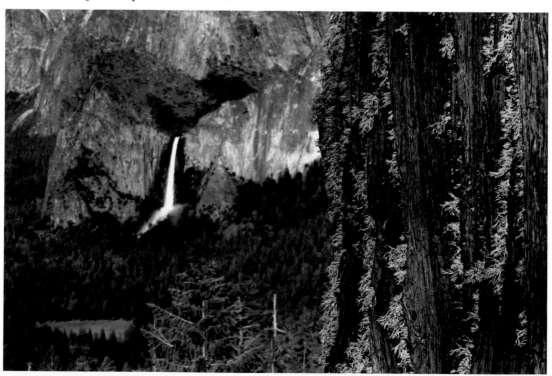

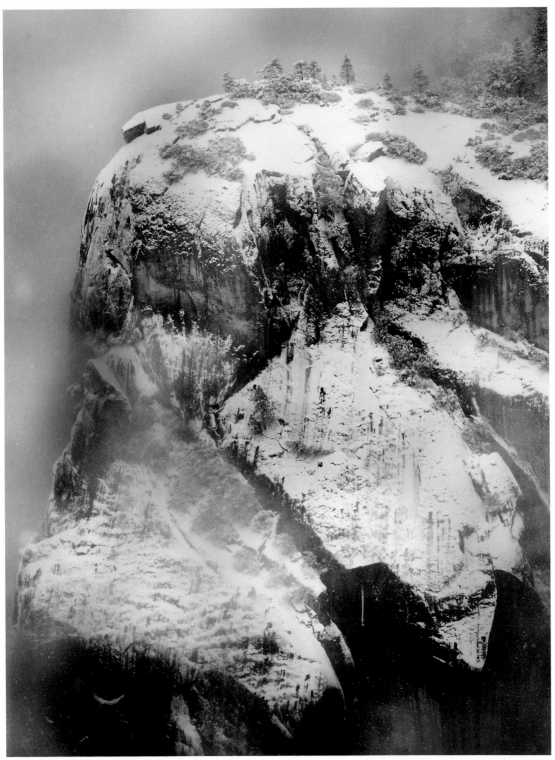

Elephant Rock

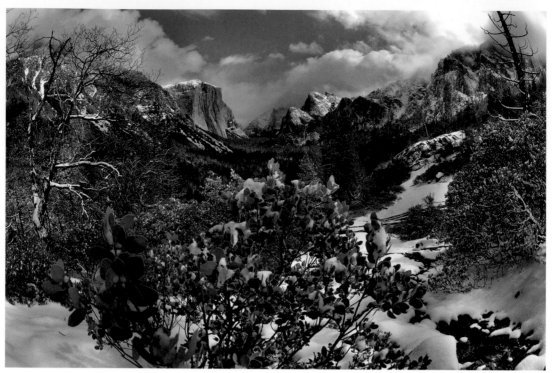

Yosemite Valley from Inspiration Point Trail

You can easily identify the vista point because it will be crowded with other photographers if the weather is at all interesting.

This is an opportunity to practice good manners as a photographer. If someone has staked out a position first, do not try to get in front of it or invade the space needed to work.

The truth is that the view from a little way up the Inspiration Point Trail is probably better than the view from the parking lot; however, almost no one from the crowd you see at the Tunnel View vista point bothers to walk even a little farther.

To find the trail to Inspiration Point, cross CA 41 to the second parking lot (being careful of traffic coming down and out of the long tunnel). You'll find the trailhead on the right-hand side near the road.

After an initial steep section, the Inspiration Point Trail climbs some 500 vertical feet gradu-

ally to the old Inspiration Point view, formerly accessed by a side road from the Glacier Point road which has been allowed to return to a natural state.

There are great views of Bridalveil Falls and Yosemite Valley from many points along the Inspiration Point Trail. The added elevation from the top of the trail allows you to take photos that are even more panoramic than those from Tunnel View. Some of my most successful photos from the Inspiration Point Trail show a foreground subject, like lichen on a tree, and a background vista of Yosemite. So when you are on the Inspiration Point Trail, look for a combination of foreground and background subject matter that forms an appealing composition.

One of the primary goals of any photographic trip to Tunnel View and Inspiration Point is to photograph Yosemite in afternoon light

with clouds and weather. So bear in mind that mountain weather changes swiftly. It's worth being patient and planning to spend an entire afternoon and evening in the Tunnel View/ Inspiration Point area if conditions are right.

As noted, the best images of Yosemite Valley from Tunnel View are created in the face of an oncoming storm or as a storm clears (like the famous Ansel Adams photograph). In these situations, the valley forests are likely dusted with new snow. However, in the summer months Yosemite is a benign place. Other than an occasional afternoon thundershower, June through September are usually free of storms.

In the winter, particularly December through March, wave after wave of wet weather originating far out to sea in the Pacific rolls across the Sierras, hitting Yosemite Valley squarely, early, and often. But Yosemite is relatively low in elevation, so all the snow in the valley may not add up to substantial accumulation; in contrast, in the high country, snow can be very deep, and sometimes persists well into the summer months.

You can't expect to get a great image of Yosemite Valley *during* a storm. Instead, try for the beginning or end of the storm. Since the prevailing weather blows from west to east—that is, into Yosemite Valley—the end of a storm is more likely to provide great landscape imagery. Herein lies a problem, because when a major snowstorm does sock Yosemite Valley, it is likely to be closed to inbound and outbound travel for a few days. So the best strategy is to monitor weather maps and forecasts. Bear in mind that major storms in Yosemite sweep in from over the Pacific Ocean. Plan to arrive in Yosemite Valley before the storm, wait it out, and photograph from Tunnel View on the afternoon of the storm's final day, hoping for good light.

Yosemite Valley from Tunnel View

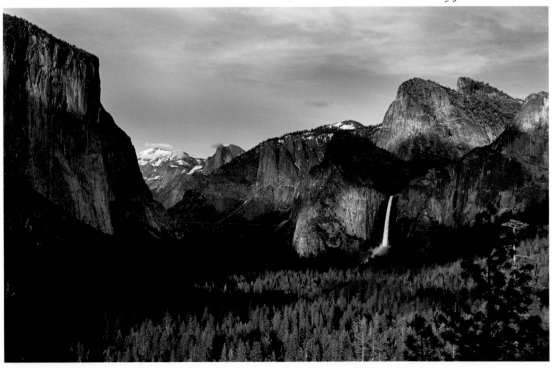

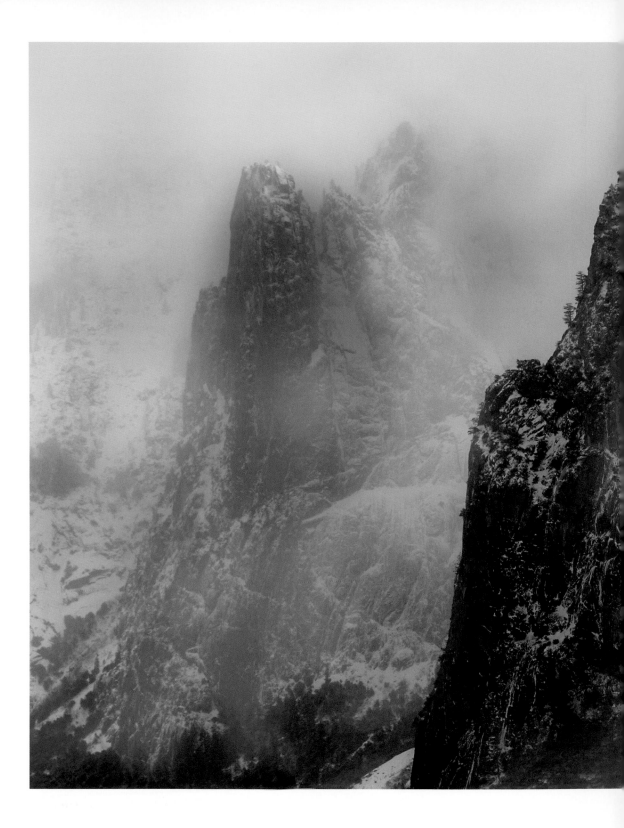

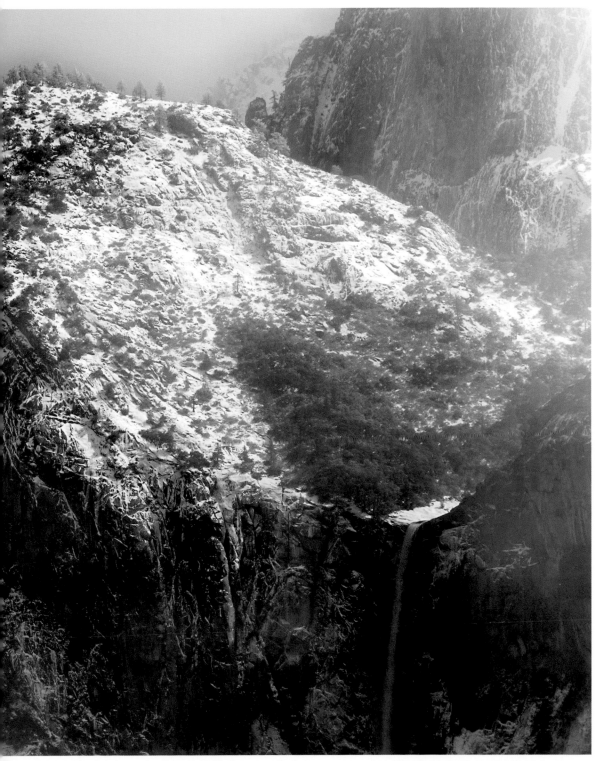

Cathedral Spires and Bridalveil Falls

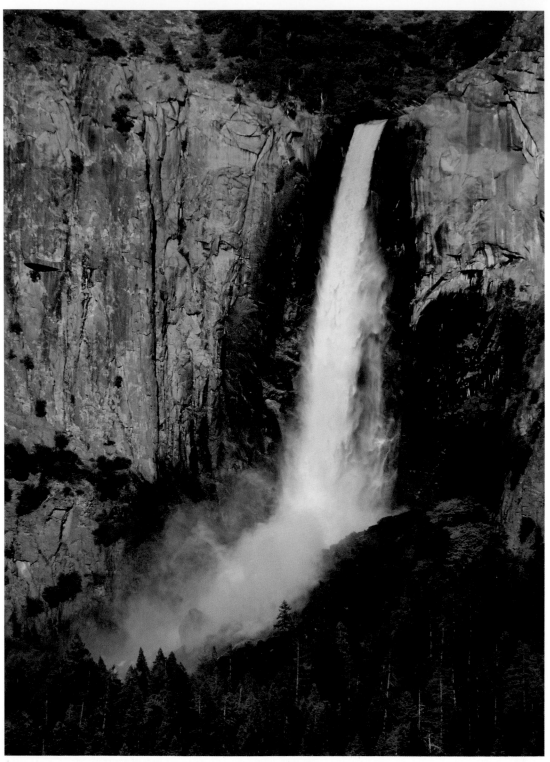

Bridalveil Falls

II. Glacier Point

Taft View and Sentinel Dome

The Valley Below

Some of the most dramatic views of Yosemite Valley, Half Dome, and the High Sierra are from Glacier Point (and along the road to Glacier Point).

During the summer, a shuttle bus runs from Yosemite Valley to Glacier Point at least twice a day, a roundtrip of about 80 miles. It's perfectly possible, and great fun, to take the shuttle bus out to the end of the road, and hike down to the valley from Glacier Point on the Panorama Trail, which meets the John Muir Trail near the top of Nevada Falls.

Directions: From Yosemite Valley, take CA 41 south out of the valley toward Wawona. At Chinquapin, take the Glacier Point road. (This road is closed in the winter.) Follow the road most of the way to Glacier Point. You'll find a parking lot at Pothole Meadows (about 20 miles from the Chinquapin turnoff) with trails marked to Taft View and Sentinel Dome.

The Hike: About one mile each way (in opposite directions) to either Taft View or Sentinel Dome.

Natural Hazards: Take great care around unprotected drop-offs to the valley floor. If you plan to photograph around sunset, when the light is probably best, be sure to bring a flashlight or headlamp so you can find your way back safely. Avoid higher areas during thunderstorms.

Area: Yosemite National Park.

View from Washburn Point

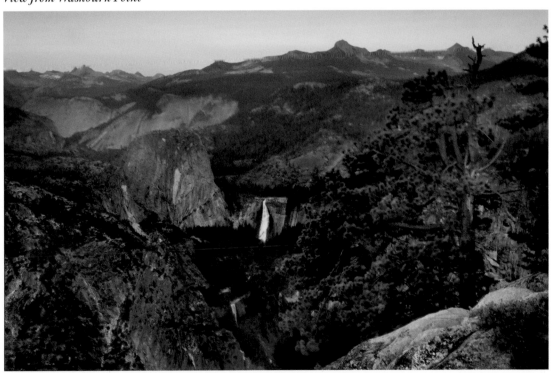

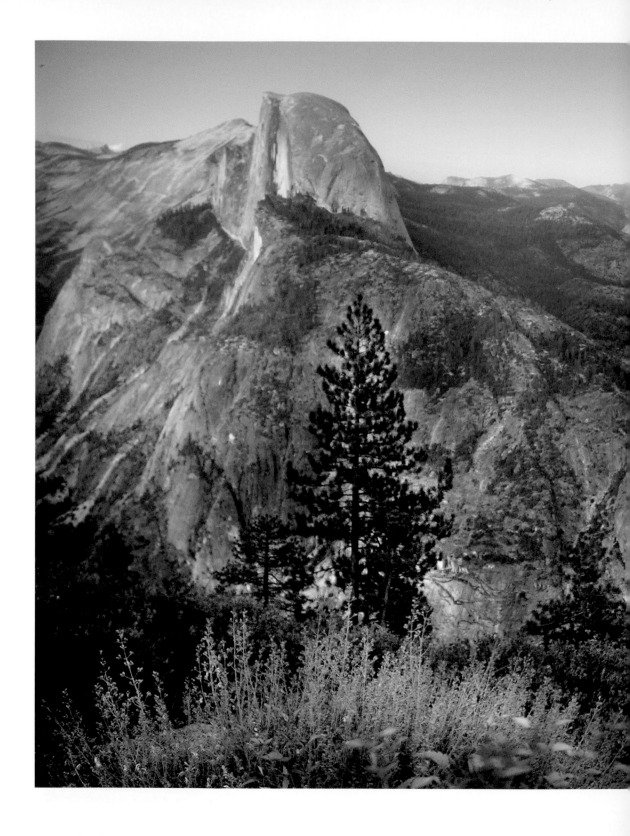

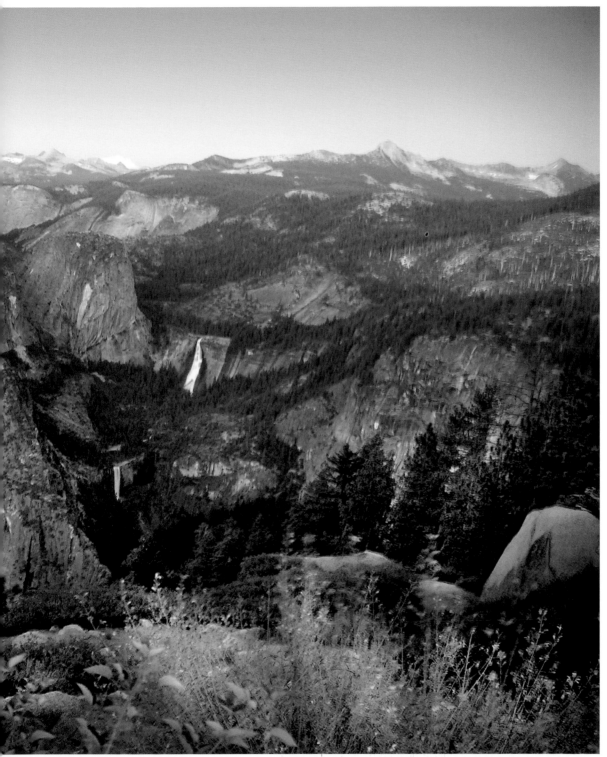

Half Dome, and Vernal and Nevada Falls from Glacier Point

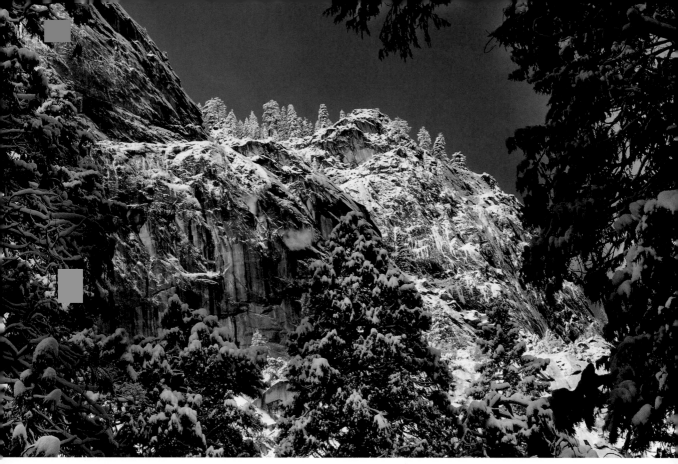

Looking up at Glacier Point

The Glacier Point road is considerably higher than Yosemite Valley and is closed for the winter once snow begins to fall in the high country. In these months, Glacier Point destinations can be reached only on cross-country skis, and may require an overnight in the snow. Note that during winter months a park shuttle bus does run as far as the Badger Pass ski area (the oldest ski facility in the state of California). If you are considering travel on the Glacier Point road outside of the summer months, inquire locally about conditions.

From the parking lot near Pothole Meadows, you can take a trail either to Taft View or Sentinel Dome (each is about 1 mile on an easy trail). If you have the time, you can of course visit both destinations, but you won't be able to photograph sunset from both places during the same session.

From Taft View there are striking perspectives down to the valley floor.

Sentinel Dome is a fairly gentle granite dome (like Half Dome, but far smaller). From the top of Sentinel Dome there is a panoramic view of Yosemite Valley and the distant High Sierra crest.

A famous and much photographed Jeffrey pine stood on top of Sentinel Dome for many years until it died in the drought years of the 1990s. You can see what's left of this tree, and try to integrate it into your compositions, from Sentinel Dome (although of course you'll never be able to have this tree living in your photograph as did Ansel Adams, among others).

Glacier Point and Washburn Point

Vast Vistas

The road to Glacier Point seems endless with only tantalizing glimpses of the high mountain crest (and none of the Yosemite Valley floor). Passing dark forest and lily-covered ponds, you wonder: "Will we ever get there?"

Yes, you will! The road narrows and turns down a steep bend. You'll see a vista of the Merced Fork of Yosemite Valley with Vernal and Nevada Falls directly below and the higher ranges of the Sierras behind. This is Washburn Point; park here to photograph at your leisure.

The road continues down another mile to the parking lot for Glacier Point, which is fairly extensively developed (a concession sells ice cream and other snacks).

There's a great deal to explore around Glacier Point from a photography viewpoint, so plan to take your time. The observation platform at the end of the paved path is protected by a stone wall, but many other spots have no protection—and it is a long way straight down to the Yosemite Valley floor!

The Glacier Point observation platform sits almost directly above Curry Village on the valley floor—if you lean over very carefully, you can eyeball the Camp Curry

Directions: From Yosemite Valley, take CA 41 south out of the valley toward Wawona. At Chinquapin, take the Glacier Point road and follow to the end.

The Hike: None for Washburn Point; about 1/8 mile for Glacier Point.

Natural Hazards: Watch for unfenced drops.

Area: Yosemite National Park.

swimming pool! (In fact, the long-standing tradition of "Firefall"—ended by the Park Service in the 1970s—involved both Camp Curry and Glacier Point: at the call "Let the fire fall!" from Camp Curry, half a ton of burning redwood fir was released over the edge from Glacier Point.) Keeping the position of Glacier Point in relation to Yosemite Valley in mind helps with orientation.

From Glacier Point, there's a good view of the valley floor as well as both forks (Tenaya and Merced) of Yosemite Valley. There's a head-on view of the sheer face of Half Dome. You can peer up the Merced Valley past Vernal and Nevada Falls. And in the distance the High Sierra crest beckons with snow-covered peaks.

Remains of the famous Jeffrey pine on Sentinel Dome in 2005

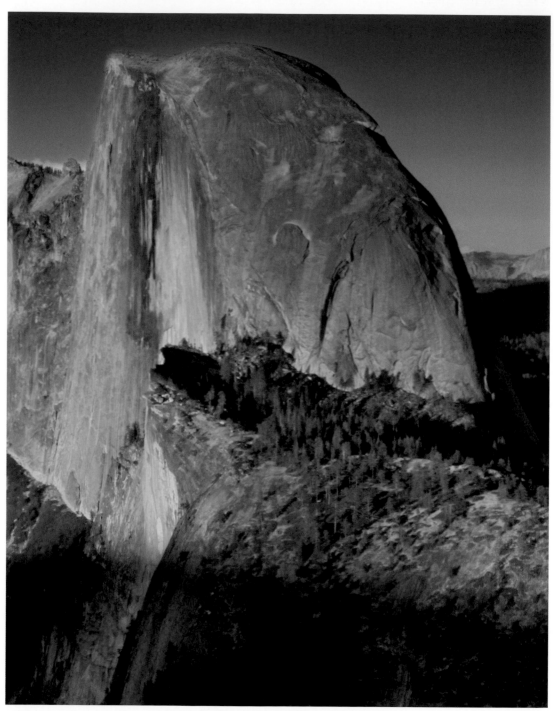

Half Dome from Glacier Point

III. Tuolumne and Tioga

Tioga Pass Road

Crossing the Western Divide

The only car road across the High Sierra crest for hundreds of miles, the Tioga Pass Road traverses some of the world's most beautiful high alpine scenery. This is mountain landscape the Sierra way: one polished rounded dome follows another, and vistas of redwood forest follow timberline landscapes with snow-capped peaks.

The Tioga Pass Road is closed at least six months out of every year, and it is a vast undertaking to dig it out from under snow, rockslides, and other winter damage. Check to see whether the road is open for the year before making travel plans.

While it's possible to drive from Yosemite Valley to Lee Vining on the eastern side of the Sierras in a few hours, most photographers (and wilderness lovers) would prefer to spend days.

A few miles past Crane Flat, you'll see the parking lot for the Tuolumne Grove of giant sequoia trees. It's 1 mile each way on a paved trail to visit the 20-some big trees.

Farther on, the road crosses Yosemite Creek. From here, you can hike down the trail to the top of Yosemite Falls, where this brook becomes the largest waterfall in the continental United States.

In general, you should plan to take your time on the Tioga Pass road. For starters, it is a classic mountain road: in places narrow, steep, and hugging precipices. Also, during the height of tourism in summer, there's a great deal of traffic. Most important from the viewpoint of a photographer: there are wonderful photographic opportunities everywhere. Keep your eye open for the delicate still lifes that can appear in the

> **Directions:** From Yosemite Valley, take the north route out of the valley toward Manteca. At Crane Flat (about 12 miles), take CA 120 headed east for Tioga Pass.
>
> **Natural Hazards:** The Tioga Pass route is closed from November through late May. Depending on when you travel, there may be no gas between Crane Flat and Lee Vining on the eastern side of the Sierras. Check your brakes before the steep, long descent to Mono Lake.
>
> **Area:** Yosemite National Park.

midst of high mountain trees and meadows. These are in contrast to broad vistas, and a true gift to the dedicated photographer.

If your taste runs to vast dramatic mountain vistas, you can find these every half-mile of the way after the road crosses Yosemite Creek. The scenery here encompasses some of the monuments of Yosemite Valley to the south and distant high mountains such as the Cathedral Range near Donahue Pass. If you observe carefully from along the road, you'll be able to place yourself (and your photographs) in the context of the grand Sierran landscape. This topography extends from the north–south Pacific crest to the perpendicular great valleys such as Yosemite and the Grand Canyon of the Tuolumne.

Lupine near Tuolumne Meadows

Olmsted Point

High-Altitude Rock and Trees

Named after famed landscape architect Frederick Law Olmsted, who spent some formative time in Yosemite, Olmsted Point is an extremely impressive and beautiful stop on the Tioga Pass road.

In one direction, you can see Tenaya Lake in its basin of granite. In the other direction, you can see the beginnings of Yosemite Valley, with Half Dome sticking up like a fin.

Olmsted Point lies on the side of Tenaya Canyon. Based on the topography visible from here, you might think it was possible to hike down Tenaya Canyon to Mirror Lake and Yosemite Valley. However, the Park Service "strongly discourages" hiking in Tenaya Canyon, which is extremely dangerous because of steep cliffs.

The view is spectacular from the Olmsted Point parking lot, but if you grab your tripod and your gear and hike around a little, you can find even better vistas.

A couple of unsigned but well-worn trails lead out of the Olmsted Point parking area. The most interesting path goes down from the parking area into a small valley, and then climbs a neighboring dome. From the top of this dome, you can see down into Tenaya Canyon, and photograph with an unobstructed view toward Half Dome.

The trees and shrubs around Olmsted Point are particularly beautiful. They are survivors,

with the wind-blown look of alpine vegetation that has made it through the winter at near timberline.

Look for photographic opportunities that combine the extraordinary vegetation of Olmsted Point with its vistas and rock formations.

Because Olmsted Point is a high-altitude setting and much of the rock here has very

Directions: Take CA 120 toward Tioga Pass. Pull off in the Olmsted Point parking lot.

The Hike: About ¼ mile to the best vista point.

Natural Hazards: Take care climbing the rocks and watch your footing.

Area: Yosemite National Park.

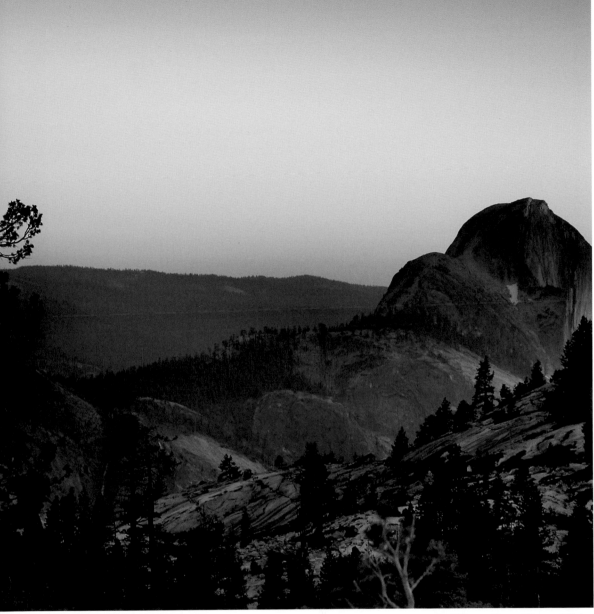

Half Dome from Olmsted Point

light tonal values, sunrise and sunset, when the light turns the rock golden, are the best times for photography. However, when you are photographing at Olmsted Point and along the Tioga Pass Road you should be especially careful about blown-out highlights (meaning loss of detail in bright areas). Check the histogram (a graph that shows the distribution of brightness and darkness in an image), and the image preview, provided by your camera. If you are blowing out highlight detail consider recomposing, or returning when the light presents more graduated tonal values. It's better to underexpose than overexpose with digital, because dark areas can be reclaimed in post-processing.

Tenaya Lake

Water and Granite

Tenaya is an often photographed and particularly beautiful High Sierra lake in a bowl of granite that is easily accessible from the Tioga Pass Road.

The primary parking lot for Tenaya Lake is at the eastern end of the lake (coming from Yosemite Valley, this means that you have driven past the lake). A short path from this parking lot leads to a sandy beach beside the lake. I recommend this beach highly for a swim on a hot summer afternoon, but for better photographic opportunities, I suggest exploring the opposite end of the lake.

The western end of Tenaya Lake tends to be less crowded than the eastern end. While there are no sandy beaches here, there are numerous shallow coves and bays, with interesting rock formations extending into the water.

Tenaya can be spectacular in difficult weather; for example, when clouds swirl over Polly and Pywiak Domes at the eastern edge of the lake. But many people remember Tenaya Lake most fondly in clear, windless weather. The lake becomes a mirror reflecting the wonders around it and within it. Most recommended accessory when photographing Tenaya Lake in clear weather: a polarizer to make those reflections look even grander than they do in life.

One of the great photographic pleasures of the Tenaya Lake and Tuolumne Meadows area is capturing water. Water in motion, such as the Tuolumne River, is always interesting, as are meadow marshes and lakes. Reflections are usually the key to photography of still water wherever you find it, particularly in lakes.

Reflections, Tenaya Lake

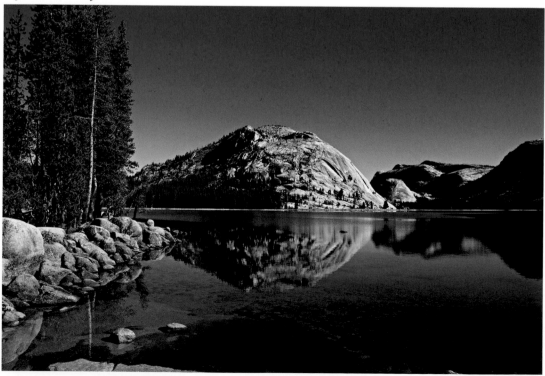

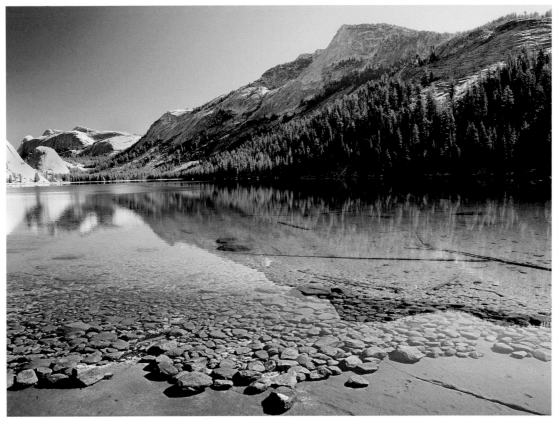

Tenaya Lake

At sunset, reflections are glorious and saturated. But you are more likely to encounter the conditions that lead to perfect reflections—still water without wind—at other times of the day, notably midmorning. The challenge with midmorning photography in the high mountains is the great exposure range from the areas in full sunshine to shadow areas.

With digital photography, you can plan in advance to deal with this exposure range in order to create images that are sometimes called High Dynamic Range (HDR). There are two basic approaches to HDR. The first is to combine several processed versions of a RAW "negative" using layers and masks to create one finished image. The second approach is to shoot a number of different exposures, using software (such as Photoshop's Merge to HDR command) to combine the best parts of the different exposures. If you follow the second approach, be sure to use a tripod and make sure that each exposure is identically framed (otherwise they can't be merged).

Directions: Take CA 120 toward Tioga Pass. Pull off in the parking lot to the east or west of Tenaya Lake.

The Hike: It is possible to walk around Tenaya Lake (about 3 miles). But there are many good photographic opportunities near where you park your car.

Natural Hazards: Note caution about hiking in Tenaya Canyon on page 58.

Area: Yosemite National Park.

Tuolumne Meadows

The Other Yosemite

Tuolumne Meadows is the "other" Yosemite, which is a way to say that while most visitors head for Yosemite Valley, in the summer the climate is better in Tuolumne, and Tuolumne Meadows is then the hub for most mountain recreation.

The Tuolumne River ambles through Tuolumne Meadows themselves, portions of which are closed to foot traffic depending on the season. In June, the wildflowers in Tuolumne Meadows inspire macro photography.

By the end of August, the meadows are brown and parched. The short mountain summer is already headed for autumn.

In winter, cross-country skiing is the only way to reach Tuolumne Meadows.

A 5-mile hike from Tuolumne to Glen Aulin

Directions: From Yosemite Valley, take CA 120 toward Tioga Pass. When you get to Tuolumne Meadows, keep going for approximately 2.5 miles until you see signs for visitor center parking.

The Hike: Many interesting hikes start in Tuolumne Meadows.

Natural Hazards: Tuolumne Meadows is at an altitude of almost 10,000 feet. Plan to take your time getting acclimated before you exert yourself heavily, and be aware that high-mountain weather (including snow) is possible at any time of year.

Area: Yosemite National Park.

leads to the Grand Canyon of the Tuolumne, past lazy river banks and many spectacular waterfalls.

Lembert Dome, at the eastern end of the meadows, can be fairly easily clambered up via the trail at the rear. Don't try to climb it from

Sunlight on the Tuolumne River

the front unless you know what you are doing, and do bring a flashlight for getting down if you plan to stay for sunset.

You can hike along the John Muir Trail back toward Nevada and Vernal Falls and Yosemite, or head south on the Muir Trail toward Donahue Pass, the High Sierra crest, and the Ansel Adams Wilderness (remember that a wilderness permit is required for overnight camping).

Another route down to Yosemite Valley from Tuolumne Meadows is to hike past Pywiak Dome, Tenaya Lake, and Olmsted Point, then down past the poetically named Cloud's Rest to meet the John Muir Trail in Little Yosemite above Nevada Falls. Yet another variation is to follow this route past the far side of Tenaya Lake, then down past Mount Watkins to meet Tenaya Creek near Mirror Lake (coming into Yosemite Valley on the opposite side of Half Dome from the John Muir Trail).

In Tuolumne Meadows itself, don't miss the Soda Springs which provides excellent, slightly carbonated mineral water, favored by Native Americans who frequented this area.

The short hike (2 miles) to Elizabeth Lake follows tumultuous Unicorn Creek to a photogenic lake beneath Unicorn Peak and Cathedral Peak. This is a wonderful short hike with varied scenery that gets you high up fast. Once again, if you plan to photograph sunset from Elizabeth Lake or along this trail, plan to bring a headlamp or flashlight to safely descend.

If you enjoy nature photography, there's probably enough in Tuolumne Meadows to keep you busy for a lifetime. The best bet is to plan to stay at least a few days. During the summer, you'll find it difficult to get a place to stay in the Tuolumne Meadows campgrounds. If you can't find a place to spend a night in Yosemite, there's almost always room in the campgrounds outside park boundaries on CA 120 heading for Lee Vining.

Tenaya Lake

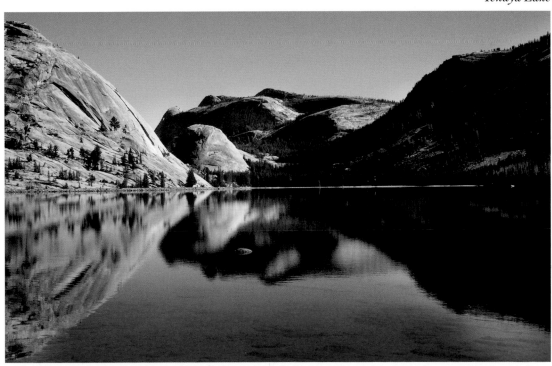

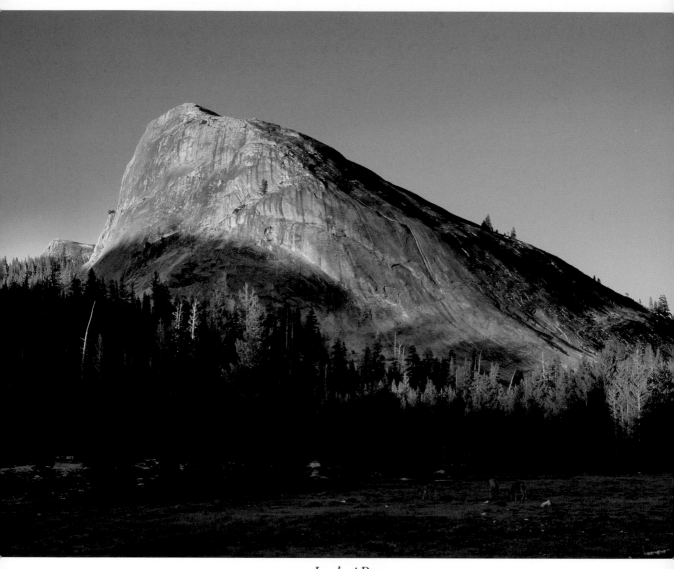

Lembert Dome

IV. Western Sierra

Kings Canyon

Hidden Canyon, Wilderness Within

A first glance, Kings Canyon may seem merely a footnote to visiting Sequoia National Park. It's true that a visit to Kings Canyon is often a side trip to the giant redwood groves of Sequoia National Park. It's also true that Kings Canyon and Sequoia National Parks are largely under joint park service administration. Beyond these superficial connections, Kings Canyon has distinctive and impressive offerings of its own to any photographer interested in nature and the wilderness.

Most of Kings Canyon National Park is rugged backcountry, accessible only by trail. This is a vast, grand high mountain territory comprising rugged peaks, stark lakes, panoramic views, and occasional windswept trees. Most visitors to Kings Canyon National Park get only a glimpse of this spectacular high country, but the trails leaving the Kings Canyon valley floor offer especially easy ways into this otherwise inaccessible realm. If you are interested in exploring the Kings Canyon backcountry, Paradise Valley and Bubbs Creek Trails are both good choices. These trails both connect to the John Muir and Pacific Crest Trails running along the High Sierra crest, and can create a loop of several days walking beginning and ending at Roads End on the Kings Canyon valley floor. (Remember that wilderness permits are required for all overnight trips to the backcountry.)

Even if you have no intention of exploring the backcountry of Kings Canyon, you'll find photographic opportunities almost anywhere along the Kings Canyon Scenic Byway. This is a road that traverses a spectacular canyon, passes roaring waterfalls, and presents views of rock walls 5,000 feet above as it crosses an otherwise empty wilderness. In particular, don't miss stopping for a good look and a photography session at Grizzly Falls, Canyon View, and Zumwalt Meadows.

> **Directions:** From Fresno, take CA 180 to Grant Grove junction. Continue east on CA 180 (the "Kings Canyon Scenic Byway") to the Cedar Grove visitor center and Roads End.
>
> **Natural Hazards:** Normal hazards of any visit to a national park.
>
> **Area:** Kings Canyon National Park.

Flowering yucca, Kings Canyon

Sequoia National Park

Biggest Trees of All

Sequoia National Park, America's second oldest national park, is rightly famous as the home of the world's largest trees, the giant redwood sequoias. But there's a great deal more to this park than "just" trees!

Sequoia's backcountry boasts some of the most beautiful and rugged terrain in the High Sierra, including the highest stretches of the John Muir Trail, and the entire High Sierra Trail.

The parts of Sequoia National Park that are accessible by road include such attractions as Crystal Cave and Moro Rock.

Moro Rock is a dome-shaped granite monolith of the type more commonly associated with Yosemite than Sequoia (though in fact granite domes occur throughout the Sierras). Moro Rock can be safely climbed following a ¼-mile trail that goes up 300 vertical feet (mostly stairs). You'll find the views from the top of Moro Rock, stretching from the peaks of the Great Western Divide out to California's central valley, highly photogenic. Be sure to bring a tripod. If you plan to stay for sunset, bring warm clothing and a flashlight or headlamp so you can safely descend.

Mariposa lily

Directions: From Visalia take CA 198 east and north to Giant Forest Village; or, from Fresno take CA 180 east to Grant Grove junction, and CA 198 south to Giant Forest Village.

Natural Hazards: Normal hazards of any visit to a national park.

Area: Sequoia National Park.

The trees are, of course, why most people visit Sequoia, and they are spectacular. The very scale of the giant redwoods, however, presents a challenge to any photographer. Even the widest of wide-angle lenses can't capture the entire height of a *Sequoiadendron giganteum*. In some cases, photographs can look better than the scene they portray, but in the case of the giant sequoia it is very hard to create an image that truly captures the magnificence of standing in front of one of these trees, let alone bettering it. The very scale of the giant sequoia beggars the imagination (and dwarfs the capabilities of optics). *This* grew from an acorn? Hah!

Here are some approaches you can consider when you visit the giant redwood forests of Sequoia and Kings Canyon.

Think carefully about your composition! Since you are cutting the tree off by necessity, think carefully about how the cropping of the tree can enhance your composition.

Consider stitching together multiple images to create a thin-but-tall "vertical panorama" of an entire tree.

Add people to your photos. A human element can add a sense of scale to the enormous trees. But be careful how you place the people in your photos, what they are wearing, and who they are—unless you are simply interested in taking snapshots of the family on vacation.

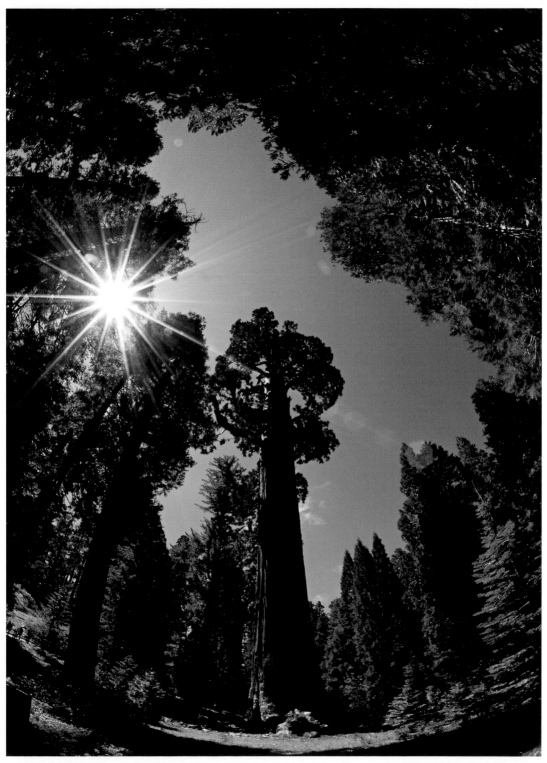

General Sherman tree, Sequoia

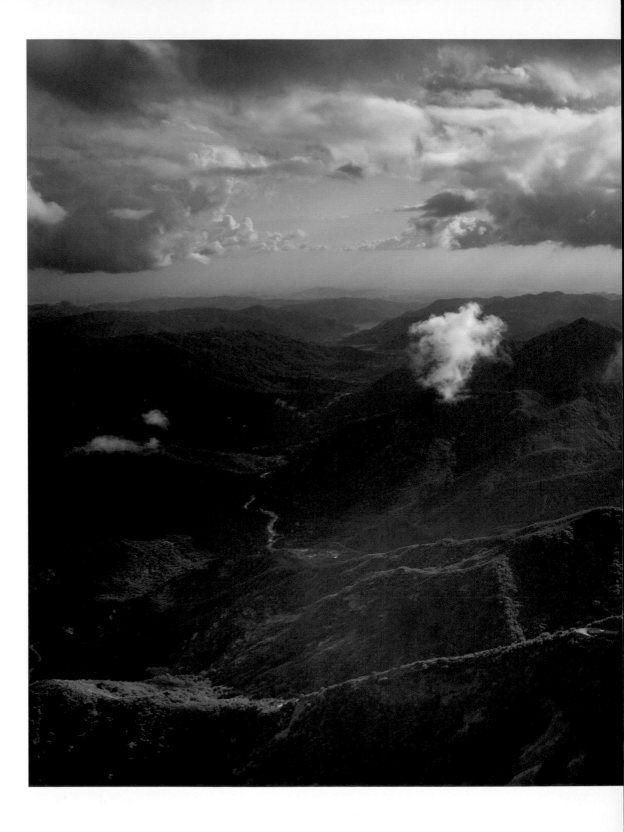

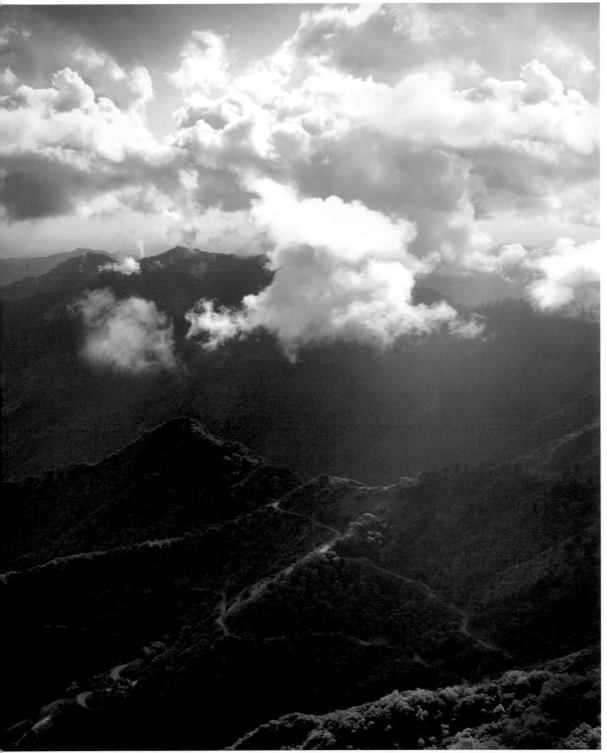

View from Moro Rock

Western Foothills

There's Gold in Them Thar Hills

The discovery of gold in California in 1848 drew thousands of prospectors to the "Mother Lode"—a strip of several hundred miles in the western foothills of the Sierras. Enough gold was found along the Mother Lode to fuel the dreams of millions and jumpstart the immigration to California that has continued to this day.

Hundreds of towns grew up along the Mother Lode; many prospered for a few years, and then failed. A few survived: for example, Sonora, Placerville, and Grass Valley.

Today, you can drive leisurely on the back roads of Mother Lode country with your camera gear packed in your car. You won't find any gold nuggets lying on the road, but you may find some gold: some of the most beautiful scenery in the world. The foothills of the Sierras are green for a brief period in the spring with new grass, then turn golden in summer and autumn as the grass dries.

It's best to plan a trip to avoid the heat of July and August, when temperatures in the western foothills can be above 100 degrees for days at a time.

Besides the unique landscape of the western Sierra foothills, you'll find evocative subjects from the human drama of the gold rush and its aftermath to photograph. Ghost towns, empty mines, buildings, and historical parks are scattered throughout the area. For example, check out the old industrial buildings in the state park at Knights Ferry (on the CA 120 approach to Yosemite) and the abandoned facades and buildings in Chinese Camp on CA 49 (as the name implies, this was a settlement of Chinese laborers in the mines).

Directions: CA 49 traverses most of the gold-rush country from Oakhurst and Mariposa to Grass Valley.

Area: Central California.

Preparing for Landscape Photography

What makes a landscape photograph special? The time around sunrise and sunset is the best time for landscape photography, but a sunset is not enough to make a great landscape photo. (How often have you looked at someone's snapshot of a sunset, and grimaced? Just another sunset....)

Be prepared to spend some time if you are really interested in making special landscape photos. Scout your locations. Understand the time of day, time of year, and ideal weather conditions for the photo. In other words, be prepared. But also be prepared to be flexible if conditions change.

Plan to spend the night. Well, maybe not the whole night, but if you are going to be photographing sunrise sometimes that's the only way. And if you will be photographing until the last light of the setting sun is gone, then you will be staying on location until after dark. Plan ahead accordingly. Pack a sleeping bag, food, light source, and warm clothing. By the way, a headlamp is by far better than a flashlight for photography, because you can manipulate the camera with your hands while aiming the light with your head.

In my trips photographing the spectacular rural landscapes of the Mother Lode—the western Sierra foothills—I've found that nature favors early spring and late autumn. At these times

of year you are likely to be the only photographer here. There will be frost in the morning and fog in the afternoons, spring colors, and unusual vistas. But I'm always prepared for winter conditions on these jaunts with a sleeping bag and adequate clothing.

Partially, this is an important safety issue because when you are on forgotten back roads chasing sunset light, you never know when you might get stuck somewhere. It's great to know that you can spend a snug and secure night with a good sleeping bag and warm clothing, and deal with finding your way back to civilization in the morning.

Fortune does favor the prepared photographer! You can't command the weather, but you can try to be in the right place at the right time (with the help of this book!). And when landscape, light, and weather cooperate, you'll be ready with the right photographic equipment, and the supplies you need to keep the photographer happy and warm.

Don Pedro Lake

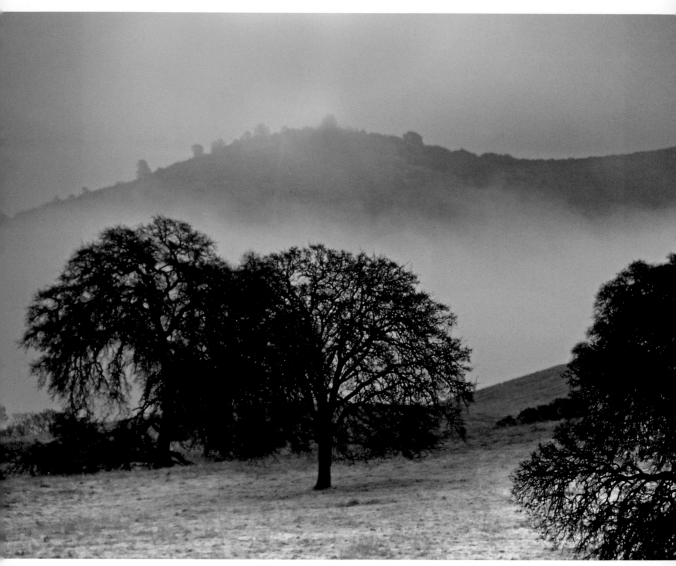

Western foothills near Chinese Camp

V. High Sierra Trails

Sierra Nevada Crest

Backcountry Travel

If you never see the backcountry of Yosemite and the Sierra Nevada crest, you will miss some of the most spectacular scenery in the world. However, it is undoubtedly true that you can't get very far into the High Sierra without overnight backpacking, and that backpacking in wilderness areas poses some significant and special challenges for photographers.

Let's take these points one at a time.

Without overnighting in wilderness areas, you are limited to how far you can hike into and then out of the mountains on the same day (with safety and comfort). This distance varies depending on many circumstances including your condition, the starting and ending elevation of your hike, trail conditions, weather conditions, and so on. But unless you are a truly experienced hiker, fully acclimated, and in good condition, you should probably consider 6 miles in and 6 miles out as something like a safe theoretical distance. For the most part, this is not far enough to reach the High Sierra crest from either the east or west sides, and will take you only a short distance along a major trail.

None of this is meant to imply that you can't approach wonderful scenery and subject matter while day hiking. But if you consider that the prime photography hours are after sunrise and before sunset, the idea of camping near your target area for photography deep in the Sierra wilderness certainly becomes attractive.

But once you are committed to overnight backpacking, there's a long list of things you'll want to carry just to survive with some comfort, including warm clothes, sleeping bag, tent, cookstove, food, and water purification pump, plus the whole rigmarole of loading and unloading your pack, setting up a tent in the wilderness, and so on. Most likely, in the Sierras a bear canister for your food will be required. In any case, you'll need to plan ahead because a wilderness permit will be required. (See the "Further Reading" and "Trip Planning Resources" appendixes on page 87 for more information about how to plan a backpacking trip and obtaining a wilderness permit.)

Carrying all this stuff can certainly make even the most free-spirited gazelles among us feel like trudging pachyderms. Add to it cameras, lens, and tripods, and even the most intrepid adventurer may think longingly of the pack animals used by photographers in the long-ago.

The truth is, of course, that modern equipment is far lighter than the plate and view cameras used by photographers of yesteryear, and that the rewards of traveling in the high country far outweigh the pain. But be prepared for the reality of the situation. If you are carrying a serious amount of photo gear on top of your backpacking kit, you will surely not have

Mount Whitney and Whitney Portal

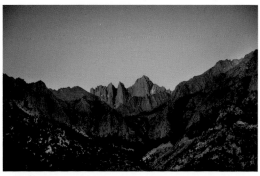

the "freedom of the hills," but will lumber along like an overloaded truck until you fall on the ground in the late afternoon and set up camp. Once camp is set up, then you can wander off, camera and tripod in hand, to photograph seldom-seen places and the wonders of timberline and above.

A possible compromise: take along a modest digital camera and leave your heavier digital SLR behind. That way you can still snap photos, quite possibly with a respectable level of megapixels, without schlepping heavy gear or worrying about ruining your expensive camera.

If you do carry a professional-level photography kit, you need to consider carefully:

- Dust and dirt
- Keeping photographic gear safe and dry
- Storage media capacity
- Power needs

Dust and dirt are the nemesis of the digital SLR because the charged sensor attracts them. You should make every effort to cover your camera with a body cap when the lens is off, and carry a cleaning kit for your camera.

Even on constantly used trails there are natural hazards like river crossings, thunder- and snowstorms, and snow fields to cross. You can't keep all possibility of harm away from your gear in these circumstances, but you should plan for nasty weather and use a protective water-resistant bag. If you are crossing a high-running creek without a bridge, take off your clothes except your boots, and mount your photo gear as high as possible on your pack, the spot least likely to get wet. (And pray!)

For digital storage, consider the average size of your image on a memory card, and how many photos you tend to take in a session. Then, allowing some extra, multiply by the number of days of your trip. You'll need to bring storage media and/or a digital wallet with sufficient capacity to match your calculations. (This is one thing that really is simpler with film. You just pack the number of rolls of film you think you'll need, along with a few extra for good luck.)

For power, you'll need to consider the capacity of the batteries that your camera uses. Make sure all batteries are fully charged before you start. Battery-charge life depends on many factors, including your style of photographing. Some of the bigger variables: How much do you review images in the LCD? How much do you use the zoom and auto focus?

You'll need to come up with an estimate based on your own camera system and photographic style. Be sure to carry at least one spare battery. Depending on your system and battery, you also might be able to use a solar recharger on the trail.

John Muir Trail

Rugged Peaks, Passes, and Mountain Lakes

You can walk the entire John Muir Trail (JMT) from Yosemite Valley to Trail Crest (north to south), or in reverse from Trail Crest to Yosemite (south to north). Note that the 211-mile figure assumes that the hike ends at Trail Crest, the highest point on any trail in the United States. You still have to descend to Whitney Portal (or

The Hike: Approximately 211 miles from Yosemite Valley to Trail Crest.

Natural Hazards: High mountain passes and exposed slopes mean dealing with altitude and weather, and other hazards of alpine travel.

Area: Yosemite National Park, Sequoia and Kings Canyon National Parks, Ansel Adams Wilderness, Inyo National Forest.

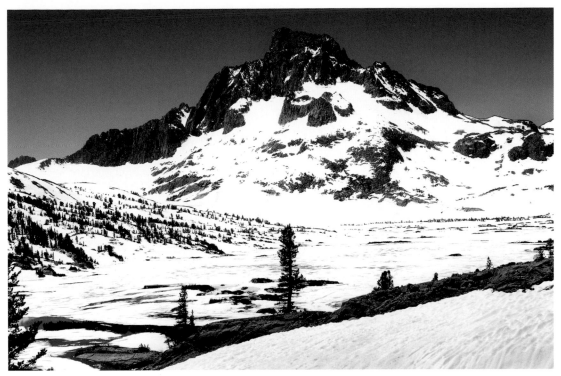

Thousand Island Lake and Mount Banner

ascend from Whitney Portal to Trail Crest if you are going the other way). So the 11 miles from Whitney Portal to Trail Crest (with a 6,000-foot elevation differential) should also be included in any mileage calculations.

Some backpackers choose to begin or end their trip at Tuolumne Meadows, eliminating the 27-mile ascent from (or descent into) Yosemite Valley. You can also hike segments of the JMT, joining it from the west or using an eastern lateral trail (the eastern laterals are probably the most direct approach into the High Sierra; see page 79).

Whichever way you approach the JMT, if you plan to overnight you will need adequate gear for safety and comfort, a wilderness permit, and a commitment to the regulations for protecting the wilderness.

As a practical matter, an experienced and prodigious hiker traveling in ultralight fashion could sprint the entire JMT in well under a week. Someone carrying heavy photographic gear and stopping to use it should probably allow more like a month. You most likely can't carry a month's worth of food with you, so if you are planning a trip of this duration you will need to arrange for resupply, either via food trips or by taking a lateral out to restock in a town such as Bishop.

The JMT passes through what may be the finest wilderness areas in the United States, near 13,000- and 14,000-foot peaks and over a number of passes above 12,000 feet. This is a land of lakes and chasms, waterfalls, canyons, granite domes and cliffs, sunshine, wind, and (for a mountain wilderness) benign weather.

If you are lucky enough to get the chance to hike the JMT, grab it. And, carry a camera.

Pacific Crest Trail

Mexico to Canada

The Pacific Crest Trail (PCT) stretches from Mexico to Canada across three states, roughly following the Western Divide. Trivia lovers may be interested in the fact that the PCT extends 8 miles into Canada's Manning Provincial Park, climbs over more than 60 major mountain passes, goes along the shores of more than a thousand substantial lakes, and is trekked end-to-end by fewer people than climb Mount Everest.

Of course, the PCT is far more than a High Sierra trail, but about 10 percent of the PCT runs through the same territory in the High Sierra as the John Muir Trail (JMT). Where possible, planners have used alternate routes. This means that you will often have a choice in any given area whether to follow the PCT or

> **The Hike:** A 2,650-mile National Scenic Trail stretching from Mexico to Canada.
>
> **Natural Hazards:** High mountain passes and exposed slopes mean dealing with altitude and weather, and other hazards of alpine travel. Careful planning is required to manage the logistics of a multi-thousand-mile hike.
>
> **Area:** California, Oregon, Washington.

the JMT, although sometimes these two famous trails run together.

Of course, you can pick and choose small sections of the PCT to hike. This is probably a wise choice if your primary interest is photography, because it is hard to carry both sufficient supplies for a long-distance trek and 20 or 30 pounds of camera gear. Long-distance trekking also adds complications to the issues of storing digital imagery safely, and keeping batteries charged.

Mount Conness from Glen Aulin

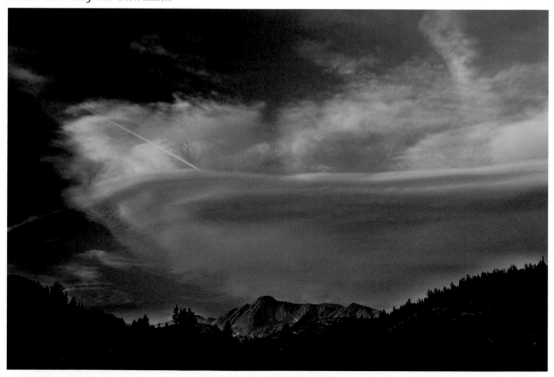

High Sierra Trail

Divides and Canyons

The High Sierra Trail leads from Crescent Meadow up the canyon of the Middle Fork of the Kaweah River, crossing the Great Western Divide at the Kaweah Gap. It drops into Big Arroyo, then climbs up to the Chagoopa Plateau, and drops down again into the Kern River Canyon.

After running up the bottom of the Kern Canyon, where one of the trip highlights is the Kern River Hot Springs, the trail climbs parallel to Wallace Creek up to the junction with the John Muir Trail (JMT), 49 miles from the starting point. You can then follow the JMT about 13 miles farther to the top of Mount Whitney, and past Trail Crest 11 miles farther to Whitney Portal.

> **Directions:** If traversing west to east, be sure to obtain a wilderness permit in advance, and locate the trailhead in Crescent Meadow near Moro Rock in Sequoia National Park (see page 66 for more information).
>
> **The Hike:** From the western slope near Sequoia National Park headquarters, the trail extends 49 miles to join the JMT and PCT below Mount Whitney near Junction Meadow.
>
> **Natural Hazards:** High mountain passes and exposed slopes mean dealing with altitude and weather, and other hazards of alpine travel.
>
> **Area:** Sequoia National Park.

This trail is an excellent and manageable way to experience the variety of the High Sierra and its range of ecologies—from west to east and at different elevations—and at the same time make your way into the heart of the High Sierra crest.

Rush Creek crossing

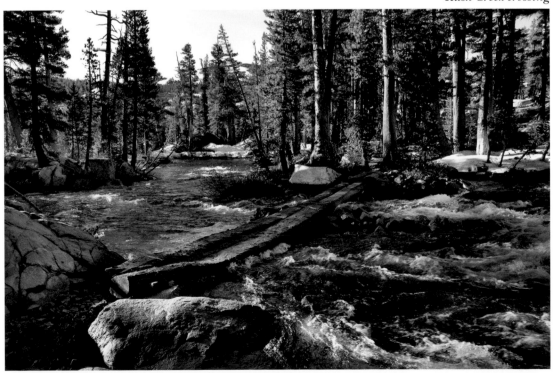

Photography in the Backcountry

I've already noted the challenges of photography in wilderness backcountry: dealing with dirt and dust, carrying and protecting gear, managing digital storage, and keeping electronic devices charged.

In addition to these difficulties, I probably should make it clear that the best photographic opportunities are also logistically complex. Be prepared for scenery in the High Sierra of staggering beauty—and ephemeral light, presenting challenges both photographic and topographic.

Sunlight in the middle of the day tends to be too bright for good results and blows out highlights. Look for weather that is mixed.

In the High Sierra, you can often predict when storms will come because you can see clouds a long way off. Also, weather systems build incrementally day after day until they finally burst. For the best opportunities look for a day of storm, followed by clearing in the late afternoon. In these conditions, try to find a high ridge (always bearing safety considerations in mind) that overlooks both a mountain panorama and a body of water (for reflections from the sky).

Don't ignore details, which are often as beautiful as the larger picture. Try to identify individual elements that are striking in themselves, and then combine these in context with the landscape. Look for images that show the vastness of the sky, snow, and granite expanses, and the stunning beauty that is the High Sierra.

Waugh Lake

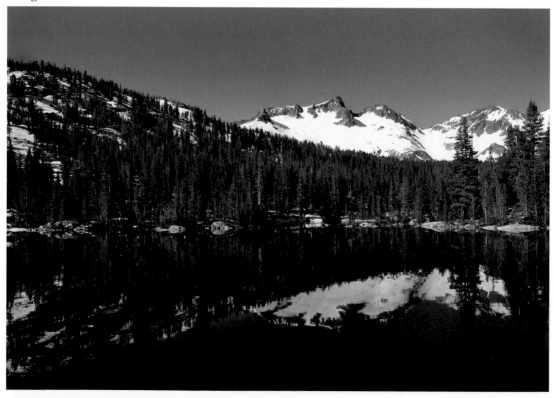

VI. Eastern Sierra and Owens Valley

The Deepest Valley

Spectacular Landscapes

East of the Sierras, the landscape changes radically. The high Sierra Nevada crest catches the moisture that has made it inland from the Pacific Ocean and across the coastal ranges and the great central California valley. The eastern Sierra is a high desert landscape created in part by the lack of water and extremes of harsh weather: hot during summer days but bitterly cold and windy in the winter. Not as bleak as the great desert wastes (such as Death Valley) lying farther east, the eastern Sierra and its contrasts are a photographic dream come true. This is one of the world's greatest landscapes.

Some of the easiest access to the High Sierra is from eastern laterals—hiking trails that lead up from the steep valleys of the eastern slope. From Whitney Portal at the southern end of the High Sierra crest, through the trailheads above Bishop, and to the high Sierra access north of Yosemite like Twin Lakes, if you want to get into the heart of the mountains fast these eastern lateral trails are the way to go. However, while short in miles, the trails are also invariably steep. In contrast to the western Sierra, where rolling foothills rise higher and higher until at last the real mountains are upon you, the eastern Sierra is a sheer wall, in places rising as much as 8,000–10,000 feet from the valley floor to the east. What an obstacle this sheer wall must have seemed to any pioneer unlucky enough to have blundered upon the eastern Sierra.

It's not surprising that these trails are based on trading routes followed by the Paiute and other indigenous peoples. Two of the gentlest eastern lateral trails over the Sierra crest

Directions: From the south (e.g., Los Angeles), drive north on US 395 up the eastern side of the Sierras. From Yosemite Valley, take CA 120 over Tioga Pass to Lee Vining. From the north (e.g., Reno and Lake Tahoe), drive south on US 395.

Natural Hazards: Owens Valley is in the high desert, with fairly extreme changes in altitude and rugged backcountry roads. If you plan to travel off the main routes, inquire locally about conditions, carry water, and be prepared for extremes of both hot and cold.

Area: Inyo National Forest, Bureau of Land Management (BLM), Mono Basin National Forest Scenic Area, private land.

and into the mountains are the Paiute Pass Trail from North Lake above Bishop and the Kearsarge Pass Trail above Independence.

I should point out that much water shortage in Owens Valley is due to human politics rather than natural forces. Owens Valley has been a source of water for Los Angeles since the 1920s, and the locus of much contention

Twin Lakes in autumn

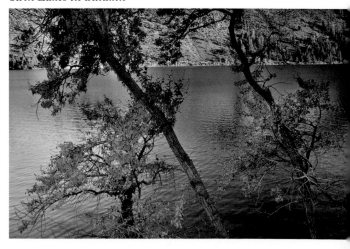

over water rights. On the one hand, the consumption of another area's water for the swimming pools and lawns of Los Angeles is to be deplored. On the other hand, there's no doubt that the lack of water has kept the area from overdevelopment, and left it a relatively pristine delight for photographers.

Mono Lake

A Wondrous Inland Sea

Mono Lake is a majestic body of water covering more than 60 square miles. With no natural outlet, fresh water from the Sierras feeding into the lake has evaporated, leaving an "inland sea" that is about two and one half times as salty as an ocean (and more than 80 times as alkaline).

Nature created the tufa towers in Mono Lake by combining the carbonates in the salty lake water with calcium from nearby freshwater springs. The tufa towers are composed of cal-

cium carbonate, and formed when a freshwater spring welled up through salty Mono Lake, since it is highly alkaline and rich in carbonates.

Starting in 1941, the city of Los Angeles began draining water from Mono Lake. By the 1980s, water levels had become so low that the ecosystem was seriously in danger. For example, islands used by nesting birds were now connected to the mainland and its predators.

In 1994, after 16 years of court battles, an agreement between Los Angeles and environmental organizations was reached that stabilized the water level at 6,392 feet above sea level for 20 years (until 2014, that is).

In light of this recent history, it's good to see that the heavy snowmelt of recent seasons has raised the level of the lake, so that waves now lap over the boardwalks and information signs in the South Tufa area. However, a great deal of work still needs to be done to preserve the wonders of this very special place.

Mono Lake is best photographed close up (to capture the tufas, volcanic formations, and birds) or from a distance (for the play of light on the lake at sunset or sunrise).

Don't forget the visitor center and nature trail, off US 395 about 1 mile north of Lee Vining, as a resource and place to gather informa-

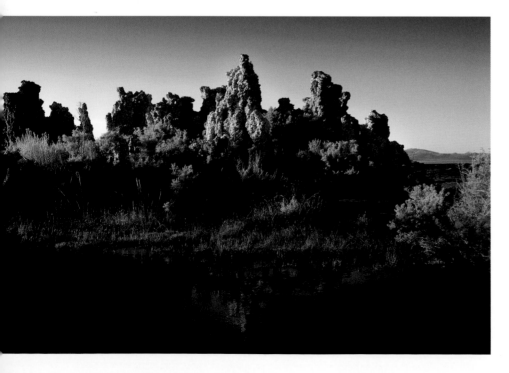

South Tufa area, Mono Lake

Mono Lake sunset

tion for photographic locations around and near the lake.

Mono Lake is a spectacular area for photography, with unique formations, great vistas, and plentiful wildlife. But don't forget the broader area around the lake itself.

Much of the country around Mono Lake is controlled by the Bureau of Land Management (BLM), meaning you can camp anywhere. It's best to explore this area with a well-equipped high-clearance four-wheel-drive vehicle, and take plenty of water.

If you are touring the area around Mono Lake, you won't want to miss Bodie State Historic Park. Once one of the largest cities in the West, Bodie is now one of the western United State's best preserved ghost towns. It is fascinating to photograph the artifacts left behind in this high desert location not far from the banks of Mono Lake.

Directions: Mono Lake lies to the east of Lee Vining, with US 395 running along the western shore of the lake and CA 167 along the northern shore. Easiest lakeside access is from the county park near the intersection of US 395 and CA 167, and from the South Tufa area.

Natural Hazards: Storms with high winds can occur on Mono Lake with surprising rapidity.

Area: Mono Basin National Forest Scenic Area.

Owens Valley

Mountains and Valley

Owens Valley is the deepest valley in the United States and an area of great variety. The exact point where Owens Valley starts is not quite clear. So, starting from Mono Lake and heading south parallel to the High Sierra crest on US 395, here are some features of interest from a photographic or logistical viewpoint.

The town of Lee Vining with restaurants, motels, gas stations, and markets sits on a bluff above Mono Lake 1 mile from the intersection with the Tioga Pass Road (CA 120) coming out of Yosemite Park.

About 5 miles south of the Tioga junction, the June Lake loop provides access to beautiful scenery as well as the trails that are the shortest way into the Ansel Adams Wilderness.

Another 15 miles south, CA 203 provides access to Mammoth Lakes, a bustling ski resort. From Mammoth Lakes, the Forest Service provides shuttle bus access to Devils Postpile National Monument, which lies up and over Minaret Summit in a long and deep valley. Both the Pacific Crest and John Muir Trail pass near Devils Postpile, so this is an excellent spot for

Alabama Hills

Directions: Owens Valley stretches down and south roughly from Mono Lake to Mojave. US 395 runs the length of the valley. Bishop is the primary town in Owens Valley.

Area: Eastern California.

accessing higher areas, or for resupplying on a long backpacking trip.

Across US 395 from the Mammoth area lies the Hot Creek Geologic Site (follow the unpaved Owens Valley Road past the Mammoth Airport for 3.5 miles). Hot Creek features thermal hot springs in the middle of a creek running down from the mountains. Currently closed to bathing because of seismic conditions, this is a place of strange beauty that is well worth a look.

A few miles south on US 395, there's a steep descent to the lower parts of Owens Valley (perhaps this is where Owens Valley proper begins).

At an elevation of about 4,000 feet, Bishop is the most important town in Owens Valley. Part Paiute reservation, Bishop is of interest to photographers as the location of Galen Rowell's Mountain Light Gallery.

East of Bishop, trails from North Lake and South Lake offer excellent access to Darwin Canyon and Evolution Valley, one of the most spectacular areas in all the Sierras.

Fifteen miles south of Bishop, you'll find the junction with CA 168 in Big Pine. Take CA 168 toward Westgard Pass en route to visit the ancient bristlecone pines in the White Mountains.

Another 30 miles south, Independence lies below Onion Valley, where you will find the trailhead for the Kearsarge Pass Trail.

Continuing a few miles south along US 395, you'll pass Manzanar National Historic Site. Manzanar was one of the concentration camps used to detain Japanese Americans during the Second World War. Well worth visiting because

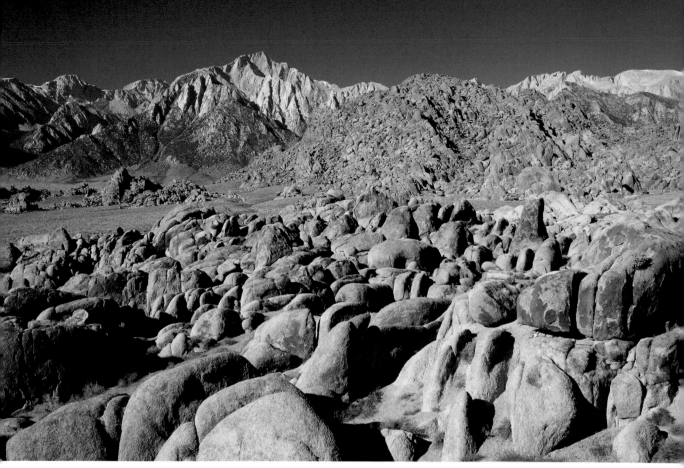

Alabama Hills with Mount Whitney in the background

of its history, Manzanar also offers superb views of the Sierra crest. Photographers may be interested to remember that Ansel Adams spent the better part of a year photographing inmates at Manzanar.

The last stop on our whirlwind tour of Owens Valley is one of the most special. The town of Lone Pine is on US 395 below Whitney Portal and the Alabama Hills. The trail up Mount Whitney starts from Whitney Portal. Even if you don't plan to climb Mount Whitney (and the required permit is hard to get during peak seasons), Whitney Portal is a place of spectacular rock formations and waterfalls.

Below Mount Whitney and Whitney Portal at the edge of the mountainscape lie the Alabama Hills. A vast field of rocks and boulders, this quintessentially American landscape has served as the backdrop for many movies, especially early westerns.

If you plan a trip to photograph the Alabama Hills, beware: you'll probably get seduced. Plan to allow plenty of time.

Photography is best in this spot in the early morning; in the afternoon the location goes into the shadow of the Sierra crest. So it is a good idea to spend the night nearby and be ready to photograph in the Alabama Hills as the sun comes up. There's an excellent National Forest Service campground a few miles up the Whitney Portal road from the Alabama Hills. Alternatively, the town of Lone Pine has become something of an arts community, and there are a great many decent motels along US 395.

Ancient Bristlecone Pine Forest

The Oldest Living Things

Bristlecone pines are the oldest living things in the world, and the largest group of these trees is high in the White Mountains on the eastern side of Owens Valley in a preserve maintained by Inyo National Forest. These gnarled and weathered specimens are endlessly photogenic, standing with a backdrop in one direction of the High Sierra, and in the other facing beyond Westgard Pass the great basins and deserts of the West.

There are two major groves of bristlecone pines in the White Mountains. The Schulman Grove (about 12 miles from the junction with CA 168) features Methuselah, the world's oldest living tree, somewhere on the 4.5-mile Methuselah Trail loop. The Forest Service has

intentionally not identified which tree is Methuselah in order to help protect it from vandalism—but all the trees are extremely ancient and very beautiful.

Directions: From Big Pine on US 395 take CA 168 toward Westgard Pass. Turn off on the road to the north that follows the crest of the White Mountains and is signed to the Ancient Bristlecone Pine Forest.

Natural Hazards: There are no services in the Ancient Bristlecone Pine Forest. In other words, you will not find gas, telephone, food, or water in the White Mountains (although you may be able to send and receive cell phone calls from Sierra Viewpoint). Cars should be equipped with emergency supplies. As with any desert travel, carry plenty of water.

Area: Inyo National Forest.

Westgard Pass

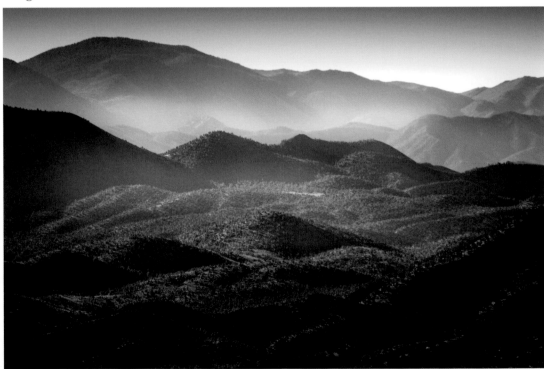

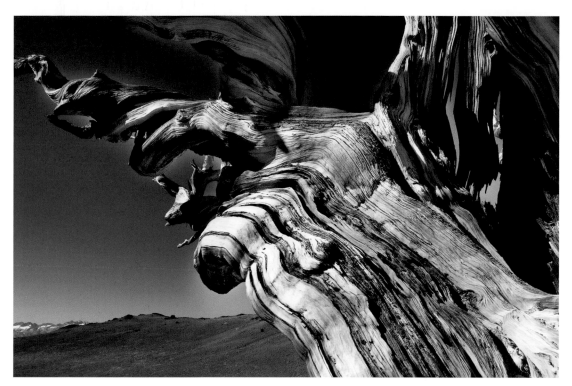

Ancient bristlecone pine

The Patriarch Grove is another 15 miles up a gravel road, and features the Patriarch Tree, the world's largest bristlecone pine.

Sunset or sunrise from a good vista spot along the White Mountain crest is a sight that you will probably remember the rest of your life. You will certainly enjoy photographing the scene. But do bear in mind if you plan to camp at the aptly named Grandview campground (the closest campsite to the groves) that the White Mountains are a harsh environment, at high altitude, with no services available. A few miles to the east beyond the turnoff for the Ancient Bristlecone Pine Preserve, SR 168 reaches Westgard Pass. Note that the last approach to the pass is a steep, one-lane grade.

Westgard Pass from above, the crest of the White Mountains stretching to the south, and the great snow-capped Sierra peaks can be seen from many spots in the Ancient Bristlecone Pine Preserve. Westgard Pass is the last stop between Owens Valley and the Sierras to the west and the great desert territory of basins and range that is Nevada and Death Valley. As such, it represents a kind of photographic boundary. To the west lie the Sierras, Yosemite, and the lushness created by Pacific Ocean precipitation. To the east lies the harsh territory of the desert, inhospitable most of the year, so dry that when it does rain the parched land cannot even absorb the water. Of course, the stark desert is a great photographic subject in its own right.

The Ancient Bristlecone Pine Preserve lies at the meeting place of these two radically different geographies and topographies. One of the challenges in photographing the ancient groves is to be able to encompass both kinds of landscape in your images.

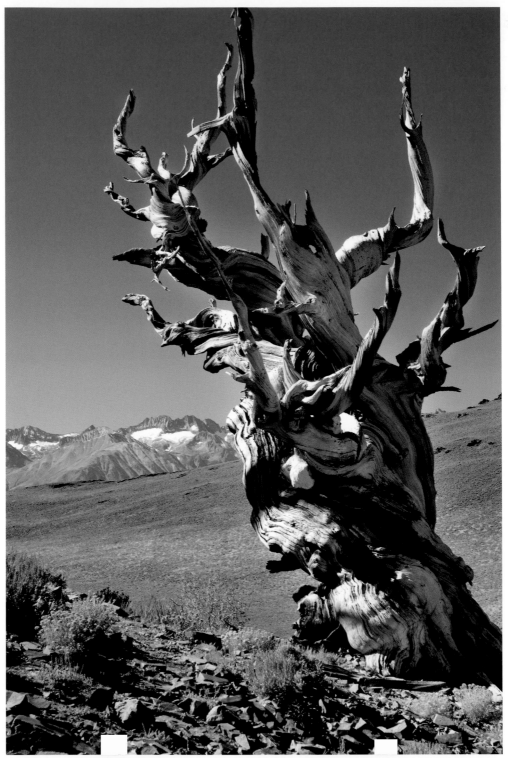

Ancient bristlecone pine with Sierras behind

Appendixes

Further Reading

Many good books will help you plan a trip to Yosemite. These guidebooks will give you useful travel logistics:

Brown, Ann Marie. *Moon Handbooks Yosemite*. Emeryville: Avalon Travel Publishing, 2006.

Wolff, Kurt; Marr, A.; Lukas, D.; and Koehler, C. *Lonely Planet Yosemite National Park*. Oakland: Lonely Planet Publications, 2003.

If you'd like to learn more about the details of photographic technique I'd suggest:

Davis, Harold. *Nature & Landscape Photography*. Sebastopol: O'Reilly Digital Media, 2007.

Shaw, John. *John Shaw's Nature Photography Field Guide*. New York: Amphoto Books, 2000.

Images created in Yosemite and the High Sierra play an important role in the history of photography. Check out these books to learn more about this role:

Adams, Ansel. *Yosemite and the High Sierra*. Boston: Bulfinch Press, 1994.

Adams, Ansel. *Yosemite and the Range of Light*. New York: Little, Brown & Co, 1992.

Klett, Mark; Solnit, Rebecca; and Wolfe, Byron G. *Yosemite in Time: Ice Ages, Tree Clocks, Ghost Rivers*. San Antonio: Trinity University Press, 2005.

Sandler, Martin W. *Photography: An Illustrated History*. New York: Oxford University Press, Inc., 2001.

Solnit, Rebecca. *River of Shadows: Eadweard Muybridge and the Technological Wild West*. New York: Penguin, 2004.

Trip-Planning Resources

Yosemite National Park

Official park web site:
www.nps.gov/yose

Lodging in the park provided by Delaware North Corporation (DNC), the park concessionaire. For reservations:
www.yosemitepark.com
559-253-5636

Camping information and reservations in the park:
www.nps.gov/archive/yose/trip/camping.htm

National Park Service campground reservations: www.recreation.gov

Wilderness trip planning:
www.nps.gov/archive/yose/wilderness/tripplanning.htm

Wilderness permit information and reservations:
www.nps.gov/archive/yose/wilderness/permits.htm
209-372-0740

Yosemite region trip planner:
www.yosemite.com/tripplan

Coyote, Yosemite Valley

Road conditions and transportation

Road conditions (check for snow closures and restrictions), Caltrans:
www.dot.ca.gov/hq/roadinfo
Inside California: 800-427-7623
Outside California: 917-445-7623

For more information about road conditions with Yosemite National Park: 209-372-0200

Tioga Pass road information:
www.nps.gov/yose/planyourvisit/
tiogaopen.htm

Conditions within Yosemite Park:
www.nps.gov/yose/planyourvisit/
conditions.htm

Public transportation to Yosemite Valley:
www.nps.gov/yose/planyourvisit/
publictransportation.htm

Mono Lake

Mono Lake web site:
www.monolake.org

Mono Lake Tufa State Reserve:
www.parks.ca.gov/?page_id=514
760-647-6331

Mono Basin National Forest Scenic Area:
760-873-2408, ext. 5

Inyo National Forest

Inyo National Forest:
www.fs.fed.us/r5/inyo
www.fs.fed.us/r5/inyo/about

Cathedral Rocks

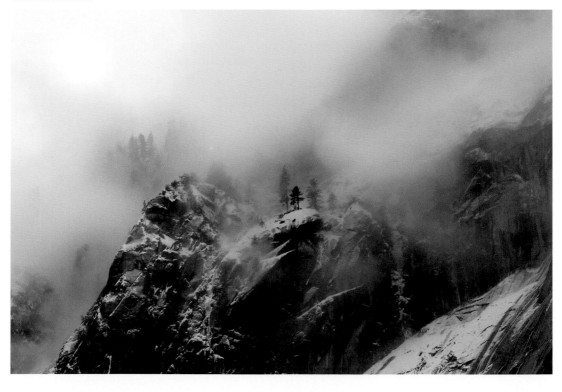

Mount Whitney Trail:
www.fs.fed.us/r5/inyo/recreation/wild/
mtwhitney.shtml

Ancient Bristlecone Pine Forest:
760-873-2500

Bureau of Land Management

Bureau of Land Management (BLM):
www.blm.gov/wo/st/en.html

BLM Alabama Hills site:
www.blm.gov/ca/bishop/scenic_byways/
alabamas.html

State Parks and National Forests

National Forests in California:
www.fs.fed.us/recreation/map/
state_list.shtml#California

National Forest Service campground
reservations: www.reserveusa.com
1-877-444-6777

California State campground
reservations: www.reserveamerica.com/
campgroundDirectoryList.do?agency=ca
1-800-444-7275

Sequoia and Kings Canyon

Sequoia and Kings Canyon National Parks
(official site): www.nps.gov/seki

Blizzard in Merced Gorge

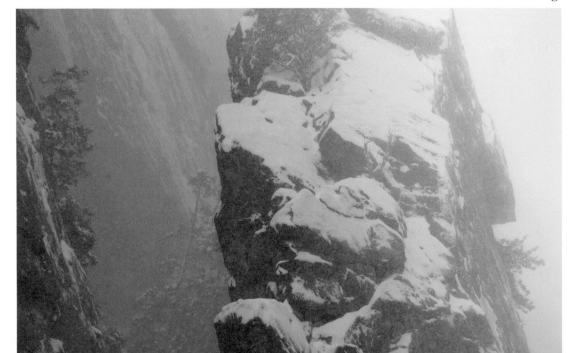

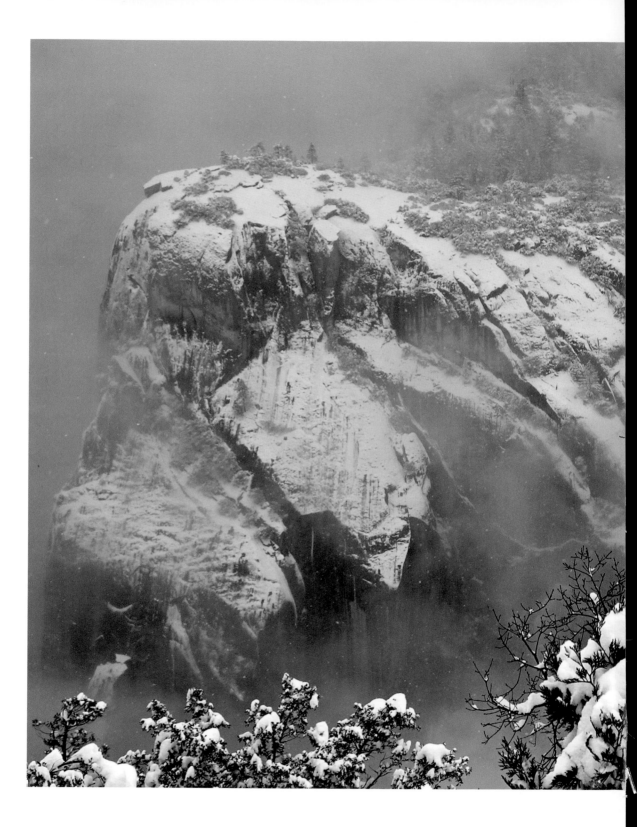

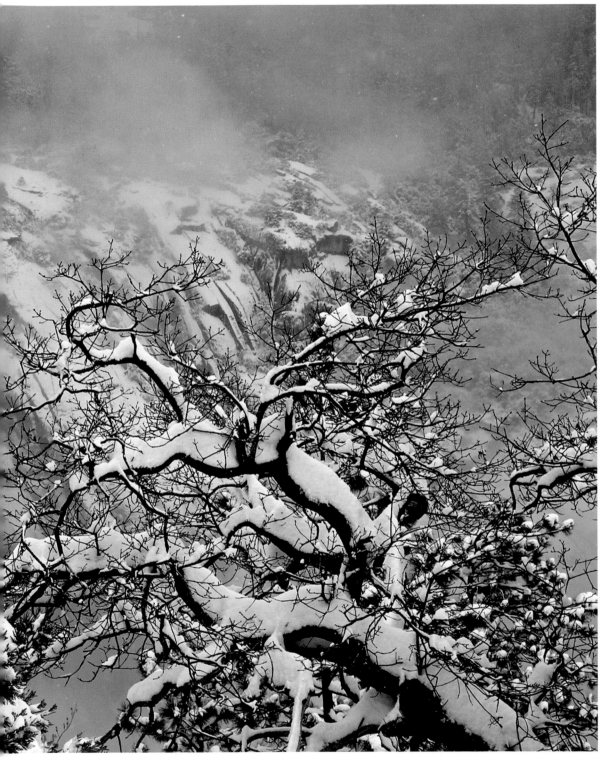

Clearing storm, Yosemite

Seasons and Natural Phenomena

Yosemite Valley

The best times to photograph Yosemite Valley are winter and spring. You'll probably find snow on the valley floor through mid-March, and February and March have more daylight than earlier in the winter season. The waterfalls will probably have peak flow in early May.

Probably the worst time to photograph Yosemite Valley is high summer. No season is truly unphotogenic in Yosemite, but you might want to consider avoiding late summer when the waterfalls may be dry (however, Vernal and Nevada Falls do flow all year), there are crowds, and the valley can be hot and hazy. The cooler high country is truly the place to be.

Tioga Pass Road, Glacier Point, and Sierra Backcountry

The High Sierra is photogenic whenever you can get there. This usually means mid-May through mid-October. Check to verify that the Tioga Pass and Glacier Point roads are open, and be prepared to deal with the possibility of snow before mid-June and after mid-September.

Owens Valley

The eastern slope of the Sierra and Owens Valley are wonderful for photography whenever you can get there, but access is considerably more circuitous in the winter months because the Tioga Pass Road is closed. You must either come up from the south (US 395 from Mojave), or carry chains across I-80 and Donner Pass (proceeding south to Mono Lake).

Vernal Falls rainbow

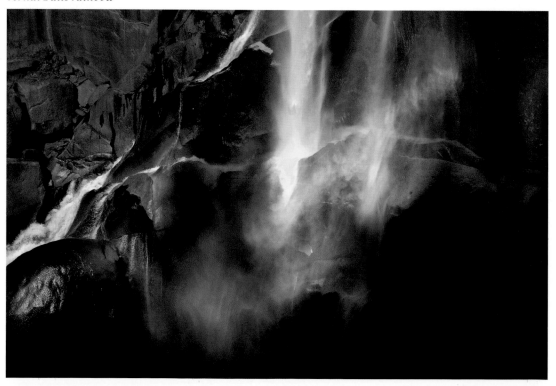

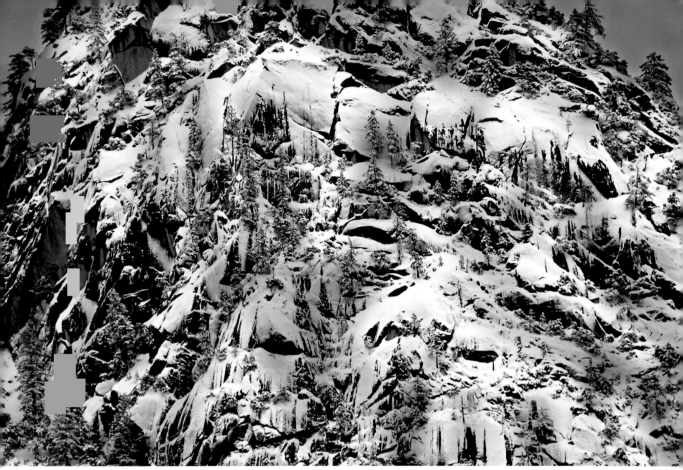

Sierra Point

Western Sierra

The western slope of the Sierra rises from California's great central valley. Photography is best in the spring, before the air gets too hazy with heat and dust from the valley.

Horsetail Falls

In the last two weeks of February, the setting sun backlights the upper portion of Horsetail Falls (1.7 miles west of Yosemite Falls on the Northside Drive). This view of Horsetail Falls, apparently lit by crimson flames, was originally made famous by photographer Galen Rowell.

You'll need a fairly long lens to get good images of this phenomenon. Also, be prepared to wait until after the sun has fully set: the show doesn't actually get going until most photographers have already given up.

Rainbows on the Mist Trail

Almost any time of year, you'll find spectacular rainbows along the Mist Trail. A polarizer will help you capture these rainbows created by Vernal Falls. As noted earlier, the polarizer is one filter whose effects can't easily be duplicated in post-processing, so it is worth investing in a good circular polarizer.

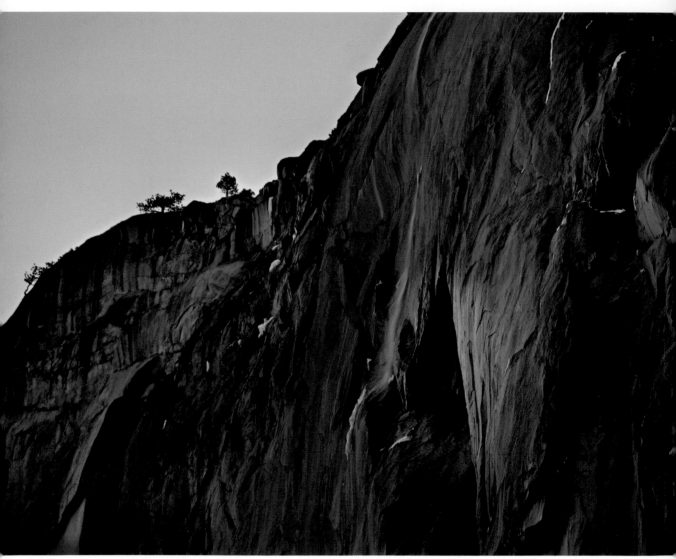

Horsetail Falls